THE INNER OCEAN

The subject of our discussion is the Ocean, which was described in the olden times as immense, infinite, the father of created things, and bounded only by the heavens; the Ocean, whose never-failing waters feed not only upon the springs and rivers and seas, according to the ancient belief, but upon the clouds, also, and in certain measure upon the stars themselves; in fine, that Ocean which encompasses the terrestrial home of mankind with the ebb and flow of its tides, and which cannot be held nor enclosed, being itself the possessor rather than the possessed.
HUGO GROTIUS

THE INNER OCEAN

PAINTINGS AND DRAWINGS BY RON BOLT

MERRITT PUBLISHING COMPANY LIMITED
TORONTO

COPYRIGHT 1979
©MERRITT PUBLISHING COMPANY LIMITED
TORONTO

PRINTED IN CANADA

DISTRIBUTED IN CANADA BY
JOHN WILEY & SONS CANADA LIMITED

CANADIAN CATALOGUING IN PUBLICATION DATA

Bolt, Ron, 1938-
The inner ocean

Bibliography: p.
Includes index.
ISBN 0-920886-00-0

1. Bolt, Ron, 1938- 2. Sea in art. 3. Ocean –
Literary collections. I. Bolt, David, 1944-
II. Title.

ND249.B59A4 1979 759.11 C79-094450-2

To Michael, Kelly and Alexander—may they always love the magic and fear the mystery.

ACKNOWLEDGEMENTS

This project presents me with the welcome opportunity to acknowledge the help of many people. Not only have they made this book possible, but their enthusiasm and encouragement have made the whole process a very enjoyable one for me.

My fascination (obsession may be a more appropriate word) with the sea began with my first trip to Newfoundland. That opportunity came about with the help of Anne Meredith Barry, an artist whose obvious love for the east coast and for life in general has had a great influence on my own directions as a painter since 1973.

Thanks to another friend of long standing, artist and architect Geoffrey Armstrong, who invited me to accompany him on an incredible three week Arctic adventure. Geoff more than proved his resourcefulness by bringing along an excellent camera which continued to function long after mine had succumbed to the rigours of an Arctic summer.

The Arctic trip would not have happened without the kind and generous assistance of Ron Willoughby, Manager, Corporate Advertising Department of Imperial Oil Limited; and his associate Brian Hay, Public Affairs Advisor, Esso Resources Canada Limited; Cameron O'Rourke, Research Director of Canadian Marine Drilling Corporation; and Art Sorensen, Director, Department of Information, Government of the Northwest Territories.

Many people have extended their hospitality to me beyond any normal bounds. They include, among others, Erik Watt, Regional Manager, Public Affairs, Indian Affairs and Northern Development in Yellowknife, and his wife Joy; Father Tardy of Holman Island and Herbert Schwarz of Tuktoyaktuk in the Northwest Territories; Captain Don Barr of the Bluenose II and his wife Trish; and Carl Miller of Bequia, The Grenadines, West Indies.

Because of the great variety of the text, I have been led into areas previously unfamiliar to me. For acting as informative and enthusiastic guides I thank Mary Maynard, Public Affairs Office, Mystic Seaport Museum, Mystic, Connecticut; Major Charles Patrick, Administration Officer, Canadian Forces Command and Staff College, Downsview, Ontario; and S. Gordon Laws, artist, photographer, and graduate first class of the Corvette navy.

Whenever I was asked to describe this project I was invariably offered a quote for possible inclusion. I am grateful for all those suggestions whether they be found in this volume or the next.

For his objective assessment of the manuscript and for his several valuable suggestions for additional material, I thank Bill Boyle, Executive Director, Visual Arts Ontario.

Several people have been inconvenienced through lending works for the time consuming process of colour separation. I trust that their frustration in having to live with the blank spaces on their walls for several weeks will be eased with the publication of this book.

Finally, this volume could not have been produced within the incredibly short time span of one year without the constant assistance of my wife Judy, who has become secretary, curator, research assistant, publicist and travel agent. In addition to assuming all these roles and more, she has done me the invaluable service of being the most diplomatic of my critics.

RON BOLT

Our purpose in creating this volume is to present as many aspects of the sea as possible and to probe the use of the sea as metaphor.

The relationship of text to image in this book varies from illustrative on the part of some of the drawings to a sympathetic vibration in the case of the paintings. A clue to this relationship is often found in the title of the image. We have purposely designed a book that can be approached on several levels: as an anthology of writings or as a survey of one artist's work. But it is our hope that the combination will lead the reader to the Inner Ocean—his own.

RON BOLT, DAVID BOLT, TORONTO, AUGUST 1979

INTRODUCTION

BY HUGH MACLENNAN

When I first saw Ron Bolt's paintings it was a spring day and the windows of his bright studio looked out over the first green grass of the year. Buds were swelling on bare branches and another winter was over. Later, I wondered if it was symbolic that I should have made my first acquaintance with Bolt's work on the first day of spring.

In the last fifteen years we have learned more about man's true place in nature than was learned in the past two thousand years. We have learned we are not nature's masters, but a part of her. And for this reason I believe that Ron Bolt is a prophetic painter.

He has returned to the mysterious, beautiful, terrifying, constantly changing sea that can be studied scientifically, its chemical components analyzed and the story of its creation told — to the sea which can be used and polluted but never destroyed, not even by technological man.

Life in the sea, as we all know, appeared long before there was any life on the land. The furrows we cut into the land can scar it for centuries. If, as is happening now, the vast tropical rain forests continue to be cut down, the air we breathe will become less than air and the earth and its living creatures may die. But the furrows we cut in the sea vanish quickly and leave no trace. Even if much of the animal and vegetable life of the planet is destroyed by fools, the sea will remain. Ultimately it could recover — this marvellous tiny planet, our home, the only place within the range of our telescopes that has any life on it.

It has often been said that the sea is unpaintable. Taken as a mere visual object this is true because it changes its outward appearance from minute to minute. What Bolt has painted is both more and less than the ocean everyone sees without seeing it at all. Though he has been labelled a "Realistic" painter — and certainly he is a wonderfully accurate one who has mastered extremely difficult techniques — he is really painting what he calls the Inner Ocean which the external sea has evoked in his mind, perhaps even in the memory traces of his subconscious.

As I moved from canvas to canvas I knew these pictures were going to stay with me for a long time, that there was so much in each of them that they could be lived with for months

and even for years. After half an hour in his studio, the Inner Ocean within myself came alive with sound and it was the *Dona Nobis Pacem* of Bach's B-Minor Mass.

More than once I have heard this music while standing on a cliff or a promontory looking down at the tide coming in. The infinite patience, the intricacy of an incoming tide, form the very pattern of the conclusion of the B-Minor Mass. This music corresponds almost exactly to a tide moving like an enormous woman unseen underneath the surface cross-currents stirred by gusts of breeze on a calm day, moving with such subtle and potent simplicity. The deep surges entwine with each other, separate, entwine again with the murmurous breathing of a most powerful being so sure of herself she is unconscious of what she is doing. When her final surge delivers all of itself to the shore, Bach's horns blazon out the climax as though the sun were singing a paean to it.

Bolt asked me to write a little about the influence of the sea in general on the literary mind and specifically about its influence on myself.

I was born within sound and smell of the sea and within less than half a mile of it; born specifically on March 20, 1907, during a blizzard that shook my father's house as a north easterly gale drove the Atlantic thundering against the rocky shores of Cape Breton Island. Exactly twenty years and two months were to pass before Lindbergh's tiny monoplane flew over my birthplace on its way to Le Bourget and still another twenty years before people began to measure the oceans by hours of flying time. Nearly everyone except professional, unionized sailors became strangers to the original mother of all living creatures and the art most admired by city-dwellers became as remote from organic life as megalopolis itself.

Though most of my working life has been lived inland, I am profoundly grateful that in my formative years I was almost never out of sight and sound of the sea. Whenever I go back to Nova Scotia an unseen weight slips off my mind. I can taste the sea in the air I breathe. As soon as possible I go down to the shore, scramble over granite rocks slippery with brine and seaweed and wash my face and hands in the ocean. In summer I take off my shirt and splash salt

water over my body and feel curiously guiltless. I was twenty-one years old and in Oxford before I knew what it was like to live away from the sea.

A number of critics have insisted that the Odysseus theme is in nearly all of my novels and when I first read this, I could make no sense of it. Years ago I wrote to that eminent critic and writer, George Woodcock, that I was merely describing the life of Nova Scotia as I had known it. I wrote that in those days mine was a province which hundreds of thousands of young men and women left in order to study or work. Most of them came home again to this place where the sea had been as much a part of their lives as it was of the lives of the classical Greeks. This, of course, was true. But now I think George Woodcock was right about me and the Odysseus theme.

When I was a boy I read few novels but devoured a good deal of literature written in Greek and Latin. By far my favourite author was Homer. He never seemed in the least remote or strange to me. Better than anyone else, Homer had described the life of many thousands of Nova Scotians and Newfoundlanders in the days before sailing ships were outmoded and the tourists came to replace them: the small ships going out from the coastal towns and villages to fish and trade, some of them on voyages that took several years to complete; the awe-inspiring storms; sailors blinded by fog, listening silently to the roar of hidden breakers on a lee-shore. Homer's "new-born, rose-fingered dawn" brought hope to many a local mariner after a night of darkness and fear. Homer had been accurately sensitive to every aspect of the sea: "the wine-dark sea", "the gray sea", "the violet sea", "the unresting sea", "the hollow ships with purple cheeks cutting their furrows in the broad-wayed sea".

All this I grew up with by reading in my adolescence (first in English and later in Greek) the father of all our western literature.

A few years after leaving Nova Scotia, homesick for the sea, I came upon some lines written by that unusual Victorian Scot, Andrew Lang, a don whose prose translation of the *Odyssey* seems to me the only one that does not entirely lose the magic of the original. The Homeric hexameter has the movement of the sea in its rhythms and

what Lang wrote of Homer came back to my mind when I contemplated Ron Bolt's pictures:

> "So gladly, from the songs of modern speech
> Men turn, and see the stars, and feel the free
> Shrill wind beyond the close of heavy flowers;
> And through the music of the languid hours
> They hear like ocean on a western beach
> The surge and thunder of the *Odyssey*."

The inspiration of the sea in western literature is so enormous that an encyclopedia would be necessary to enumerate even a fraction of its details.

Our western literature, nearly all modes of it, was born on the shores and small islands of the Mediterranean and most of the literature of our own language came from England herself, the most important island in the world. People who live by the sea are not romantic about it. Nor has it occurred to them that one of the sea's major modern functions would be to provide rich city dwellers with vacation beaches lined with gambling casinos.

I asked Ron why he had come to paint the sea and this is some of what he wrote to me in an answering letter:

"There is also the mystery. The idea that man's veneer of civilization is perilously thin. His buildings, communication systems, production capabilities, cannot ultimately protect him from the wilderness. Rivers still overflow, the desert encroaches slowly, the winter storm is only an empty oil barrel away and the sea can kill you in a second. One of the wildest spots I have seen is Peggy's Cove. In July slippery rocks are alive with tourists in leather oxfords and fragile sandals. The days are warm and sunny and the sea lies there like a great purring cat ready to pounce. The people who visit the cove have, from my observations of their actions, no appreciation whatsoever of the forces they flirt with".

Peggy's Cove, the tiny village outport built on granite some thirty miles by road from Halifax, is now a famous place approached by a modern highway. It became famous because a few artists discovered it in the 1920s. One of them was a boyhood friend of mine and we used to go out there regularly, he to paint and I to wander around and look. The fishermen

left their cove at dawn and returned with their catches in the late afternoons. If the weather was fine, we used to see them sitting silently on the jetties or even on the rock near the lighthouse. They seldom spoke. They knew each other so well that speech was unnecessary. They sat motionless with the sea in their eyes. One old man I knew, his face and hands bleached gray by the winds, storms and suns of more than eighty years, said quietly without regret: "Hard? yes, it has been hard". In his cabin where the dark stains of the old whale oil lamps still remained on the walls, he had a small library of well-worn books, among them collections of Shakespeare's plays, many novels of Dickens, *Gulliver's Travels*, a book with all the poems of Milton and, of course, the Bible. The afternoon was clear without a cloud and looking up he said, "There's going to be a blow soon". I asked how he knew this, for he had no radio to tell him the weather and wouldn't have trusted it if he had. "The light", he said. "When the light is like polish on the sky, there's a blow coming on". In those days in Halifax I used to sleep summer and winter in a tent in the family back yard and sure enough, in the small hours of the next morning I was wakened by a rainstorm with the wind straining so hard on the canvas I wondered if it would blow my tent down.

While in the midst of writing and thinking about how to do justice to Ron Bolt's painting, I decided to re-read the *Odyssey*. It must have been thirty-five years since I re-read it consecutively. My Greek was woefully rusty, but working back and forth between the Greek and the English in a Loeb Classical Library edition, I re-read at least half of the epic and what struck me most about it now was something that had not struck me at all when I was young. It was Homer's astonishing accuracy of observation. Underneath his framework of mythology, there is a superb creation of the characters of men living violently with their own natures and the infinitely greater violence of nature itself, especially the sea. For several days I became totally absorbed in the *Odyssey*.

One night my wife woke up because she had heard a great crash. I had flung out my arm when asleep and nearly knocked over the bedside table. "What's the matter?" she cried. "Are you alright?" Half asleep and half awake, I said, "I've just had a dream. I'm not out of it yet".

In recent years I dream much less than when I was younger, but this particular dream made up for much lost time. It began with a distorted recollection of one of Bolt's storm scenes. Then it shifted into Homer. Then the sail of the Homeric ship turned into a twentieth century liner of the kind that used to spend seven days taking me from Halifax to Southampton before the war and the airliners came along. On just such a ship—she was called the Pennland and was bombed to death off Crete in 1941—I was travelling in my dream. Suddenly I saw looming up a huge mountain of water. It was directly windward of the ship and broadside on, and it was advancing relative in size to the Pennland as a wave a hundred feet high would be to a fishing boat. The sides of this sea mountain were scored with deep, fast-changing valleys of water. Its crest—it was at least a thousand feet high—was beginning to topple over. The captain had seen it coming and had put over his helm in an attempt to meet it head on. "He can never climb the sides of that!" I thought. Then the vast wave arrived. The ship vanished and myself with it and for what seemed like many minutes there was total blackness. Then some enormous unseen force blew me up out of the water into the air. I was sailing through the air looking down at the sea mountain when suddenly it vomited out of itself the keel of the broken ship and I wondered why the keel was white. Then everything went black again and I heard my wife asking me what was the matter.

Hours later during the following day it occurred to me that nothing at all was the matter. It was merely that the combination of Ron Bolt's paintings and several days of re-reading Homer had brought me to a more accurate assessment of the precariousness of my own tiny place in this world where all the continents are mere islands in the vast and unpredictable ocean.

HUGH MACLENNAN MONTREAL MAY 1979

TIDE

Lovers
and lesser men
have gone on and on
endlessly and persuasively

About the anguished
half-choked
sputtering cry
the circumscribed tide
makes — its hiss
and last sigh —
before it collapses
on the white sand
and dies

I note only
what happens
to the bright refractions
of light

When the dashed water
lies momentarily low
slow-moving and still
on its dull supporting porous table

IRVING LAYTON

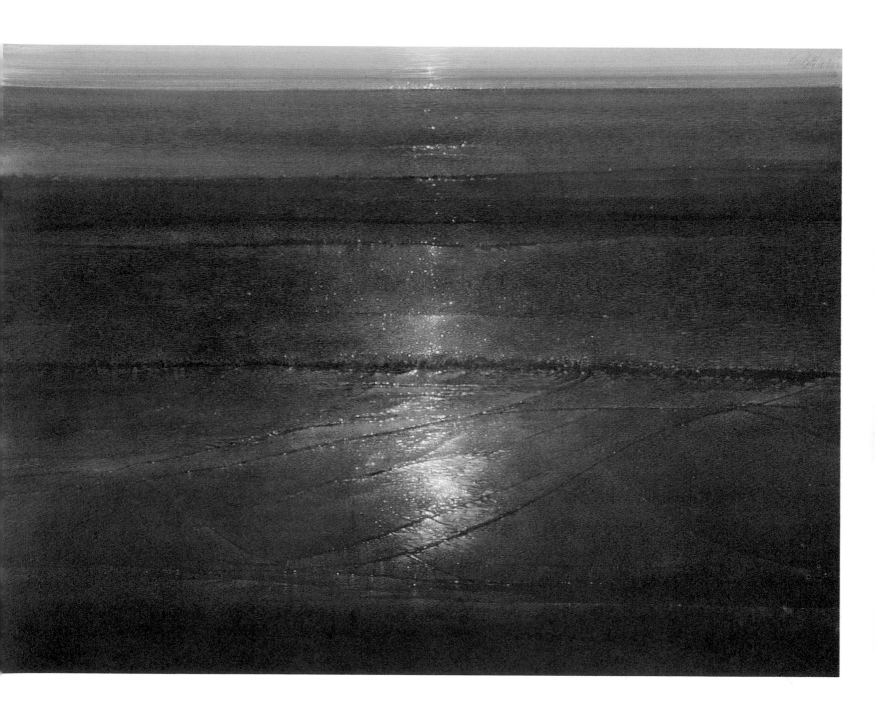

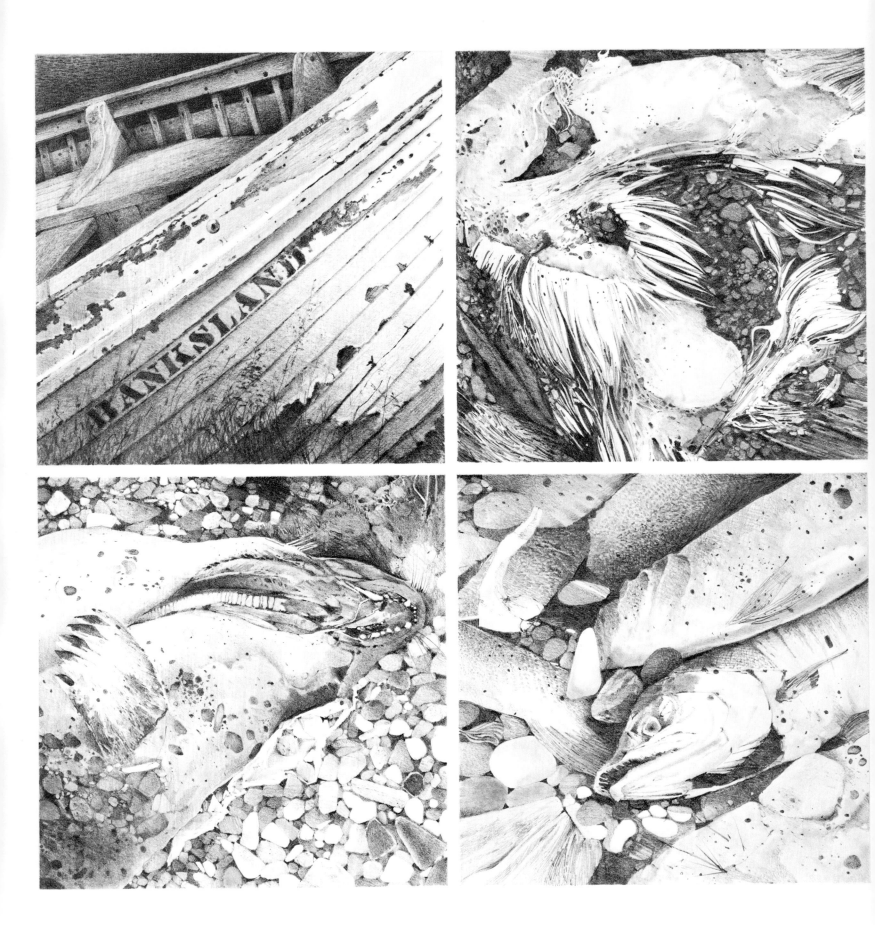

The seashore is a sort of neutral ground, a most advantageous point from which to contemplate this world. It is even a trivial place. The waves forever rolling to the land are too far-traveled and untamable to be familiar. Creeping along the endless beach amid the sun-squawl and the foam, it occurs to us that we, too, are the product of sea-slime.

It is a wild, rank place, and there is no flattery in it. Strewn with crabs, horse-shoes, and razor-clams, and whatever the sea casts up—a vast *morgue,* where famished dogs may range in packs, and crows come daily to glean the pittance which the tide leaves them. The carcasses of men and beasts together lie stately up upon its shelf, rotting and bleaching in the sun and waves, and each tide turns them in their beds, and tucks fresh sand under them. There is naked Nature — inhumanly sincere, wasting no thought on man, nibbling at the cliffy shore where gulls wheel amid the spray.

HENRY DAVID THOREAU

THE SEA FOGS

A change in the colour of the light usually called me in the morning. By a certain hour, the long vertical chinks in our western gable, where the boards had shrunk and separated, flashed suddenly into my eyes as stripes of dazzling blue, at once so dark and splendid that I used to marvel how the qualities could be combined. At an earlier hour the heavens in that quarter were still quietly coloured, but the shoulder of the mountain which shuts in the cañon already glowed with sunlight in a wonderful compound of gold and rose and green; and this too would kindle, although more mildly and with rainbow tints, the fissures of our crazy gable. If I were sleeping heavily, it was the bold blue that struck me awake; if more lightly, then I would come to myself in that earlier and fairer light.

One Sunday morning, about five, the first brightness called me. I rose and turned to the east, not for my devotions, but for air. The night had been very still. The little private gale that blew every evening in our cañon, for ten minutes or perhaps a quarter of an hour, had swiftly blown itself out; in the hours that followed not a sigh of wind had shaken the tree-tops; and our barrack, for all its breaches, was less fresh that morning than of wont. But I had no sooner reached the window than I forgot all else in the sight that met my eyes, and I made but two bounds into my clothes, and down the crazy plank to the platform.

The sun was still concealed below the opposite hill-tops, though it was shining already, not twenty feet above my head, on our own mountain slope. But the scene, beyond a few near features, was entirely changed. Napa Valley was gone; gone were all the lower slopes and woody foothills of the range; and in their place, not a thousand feet below me, rolled a great level ocean. It was as though I had gone to bed the night before, safe in a nook of inland mountains, and had awakened in a bay upon the coast. I had seen these inundations from below; at Calistoga I had risen and gone abroad in the early morning, coughing and sneezing, under fathoms on fathoms of grey sea-vapour, like a cloudy sky—a dull sight for the artist, and a painful experience for the invalid. But to sit aloft one's self in the pure air and under the unclouded dome of heaven, and thus look down on the submergence of the valley, was strangely different, and even delightful to the eyes. Far away were hill-tops like little islands. Nearer, a

smoky surf beat about the foot of precipices and poured into all the coves of these rough mountains. The colour of that fog-ocean was a thing never to be forgotten. For an instant, among the Hebrides and just about sundown, I have seen something like it on the sea itself. But the white was not so opaline; nor was there, what surprisingly increased the effect, that breathless, crystal stillness over all. Even in its gentlest moods the salt sea travails, moaning among the weeds or lisping on the sand; but that vast fog-ocean lay in a trance of silence, nor did the sweet air of the morning tremble with a sound.

As I continued to sit upon the dump, I began to observe that this sea was not so level as at first sight it appeared to be. Away in the extreme south, a little hill of fog arose against the sky above the general surface, and as it had already caught the sun, it shone on the horizon like the topsails of some giant ship. There were huge waves, stationary, as it seemed, like waves in a frozen sea; and yet, as I looked again, I was not sure but they were moving after all, with a slow and august advance. And while I was yet doubting, a promontory of the hills some four or five miles away, conspicuous by a bouquet of tall pines, was in a single instant overtaken and swallowed up. It appeared in a little, with its pines, but this time as an islet, and only to be swallowed up once more, and then for good. This set me looking nearer, and I saw that in every cove along the line of mountains the fog was being piled in higher and higher, as though by some wind that was inaudible to me. I could trace its progress, one pine-tree first growing hazy and then disappearing after another; although sometimes there was none of this forerunning haze, but the whole opaque white ocean gave a start and swallowed a piece of mountain at a gulp. It was to flee these poisonous fogs that I had left the seaboard, and climbed so high among the mountains. And now, behold, here came the fog to besiege me in my chosen altitudes, and yet came so beautifully that my first thought was of welcome.

The sun had now gotten much higher, and through all the gaps of the hills it cast long bars of gold across that white ocean. An eagle, or some other very great bird of the mountain, came wheeling over the nearer pine-tops, and hung, poised and something sideways, as if to look abroad on that unwonted desolation, spying, perhaps with terror, for the eyries of her comrades. Then, with a long cry, she

disappeared again towards Lake County and the clearer air. At length it seemed to me as if the flood were beginning to subside. The old landmarks, by whose disappearance I had measured its advance, here a crag, there a brave pine-tree, now began, in the inverse order, to make their reappearance into daylight. I judged all danger of the fog was over. This was not Noah's flood; it was but a morning spring, and would now drift out seaward whence it came. So, mightily relieved, and a good deal exhilarated by the sight, I went into the house to light the fire.

I suppose it was nearly seven when I once more mounted the platform to look abroad. The fog-ocean had swelled up enormously since last I saw it; and a few hundred feet below me, in the deep gap where the Toll House stands and the road runs through into Lake County, it had already topped the slope, and was pouring over and down the other side like driving smoke. The wind had climbed along with it; and though I was still in calm air, I could see the trees tossing below me, and their long, strident sighing mounted to me where I stood.

Half an hour later, the fog had surmounted all the ridge on the opposite side of the gap, though a shoulder of the mountain still warded it out of our cañon. Napa Valley and its bounding hills were now utterly blotted out. The fog, sunny white in the sunshine, was pouring over into Lake County in a huge ragged cataract, tossing tree-tops appearing and disappearing in the spray. The air struck with a little chill, and set me coughing. It smelt strong of the fog, like the smell of a washing-house, but with a shrewd tang of the sea-salt.

Had it not been for two things — the sheltering spur which answered as a dyke, and the great valley on the other side which rapidly engulfed whatever mounted — our own little platform in the cañon must have been already buried a hundred feet in salt and poisonous air. As it was, the interest of the scene entirely occupied our minds. We were set just out of the wind, and but just above the fog; we could listen to the voice of the one as to music on the stage; we could plunge our eyes down into the other as into some flowing stream from over the parapet of a bridge; thus we looked on upon a strange, impetuous, silent, shifting exhibition of the powers of nature, and saw the familiar landscape changing from moment to moment like figures in a dream.

ROBERT LOUIS STEVENSON

THE WORLD BELOW THE BRINE

The world below the brine,
Forests at the bottom of the sea, the branches and leaves,
Sea-lettuce, vast lichens, strange flowers and seeds, the thick tangle,
 openings, and pink turf,
Different colors, pale gray and green, purple, white, and gold, the
 play of light through the water,
Dumb swimmers there among the rocks, coral, gluten, grass, rushes,
 and the aliment of the swimmers,
Sluggish existences grazing there suspended, or slowly crawling
 close to the bottom,
The sperm-whale at the surface blowing air and spray, or disporting
 with his flukes,
The leaden-eyed shark, the walrus, the turtle, the hairy
 sea-leopard, and the sting-ray,
Passions there, wars, pursuits, tribes, sight in those ocean-depths,
 breathing that thick-breathing air, as so many do,
The change thence to the sight here, and to the subtle air breathed by
 beings like us who walk this sphere,
The change onward from ours to that of beings who walk other
 spheres.

WALT WHITMAN

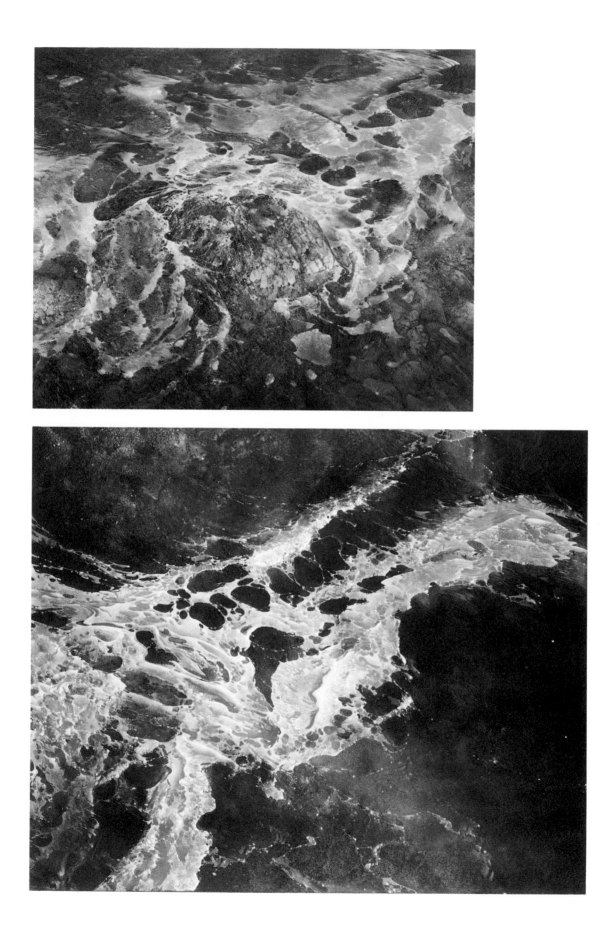

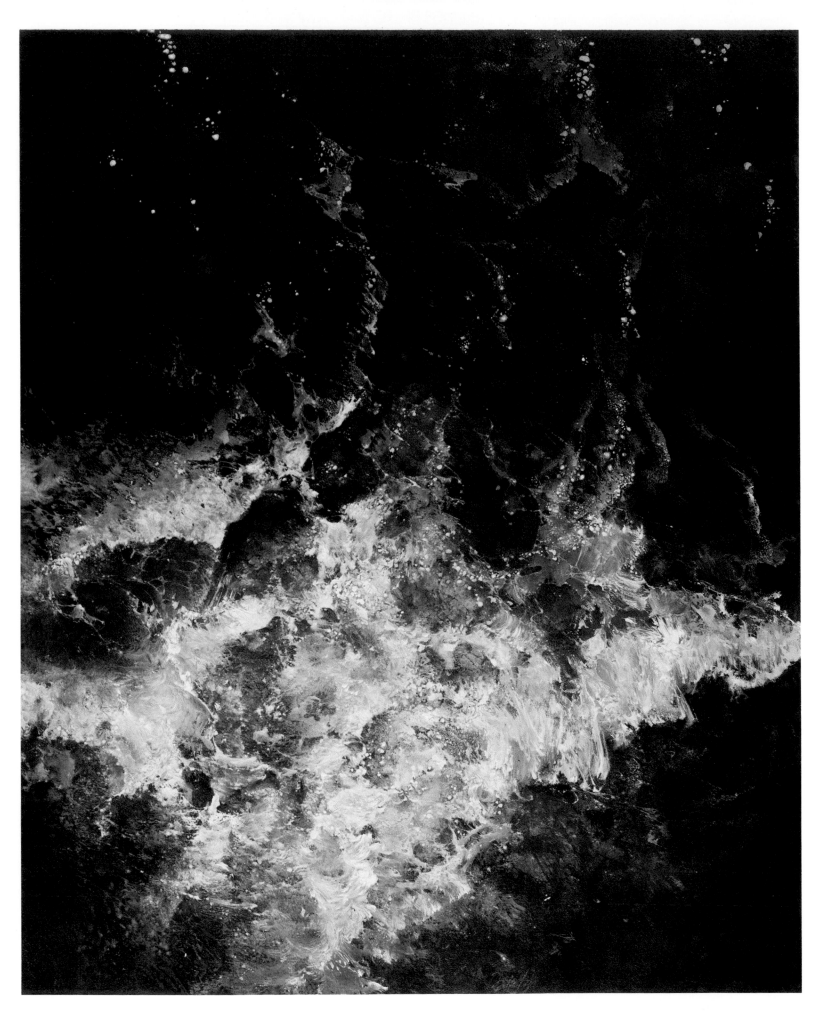

THE OCEAN

The ocean was bottomlessly deep.
Standing at the edge of the ocean
I looked toward the bottom of the ocean.

Dangerously near tumbling off,
what I thought of was the things of my future.
Time was imagined like the legs of an infant
who has not yet walked.

No matter what happens anywhere
there is nothing else to do
but stand on this steep cliff, clench my teeth,
and close my eyes.

The unexperienced future
like fishermen's fires flickering past the horizon
has darkness around itself.

I seem to have thrown my body down into that ocean.

SHINKICHI TAKAHASHI

I have lived by the sea-shore and by the mountains. No,—I am not going to say which is best. The one where your place is, is the best for you. But this difference there is: you can domesticate mountains, but the sea is *ferae naturae*. You may have a hut, or know the owner of one, on the mountain-side; you see a light half-way up its ascent in the evening, and you know there is a home, and you might share it. You have noted certain trees, perhaps: you know the particular zone where the hemlocks looked so black in October, when the maples and beeches have faded. All its reliefs and intaglios have electrotyped themselves in the medallions that hang round the walls of your memory's chamber. — The sea remembers nothing. It is feline. It licks your feet, — its huge flanks purr very pleasantly for you; but it will crack your bones and eat you, for all that, and wipe the crimsoned foam from its jaws as if nothing had happened. The mountains give their lost children berries and water; the sea mocks their thirst and lets them die. The mountains have a grand, stupid, loveable tranquillity; the sea has a fascinating, treacherous intelligence. The mountains lie about like huge ruminants, their broad backs awful to look upon, but safe to handle. The sea smooths its silver scales, until you cannot see their joints, — but their shining is that of a snake's belly, after all. — In deeper suggestiveness I find as great a difference. The mountains dwarf mankind and fore-shorten the procession of its long generations. The sea drowns out humanity and time; it has no sympathy with either; for it belongs to eternity, and of that it sings its monotonous song for ever and ever.

Yet I should love to have a little box by the seashore. I should love to gaze out on the wild feline element from a front window of my own, just as I should love to look on a caged panther, and see it stretch its shining length, and then curl over and lap its smooth sides, and by-and-by begin to lash itself into rage and show its white teeth, and spring at its bars, and howl the cry of its mad, but, to me, harmless fury. — And then,—to look at it with that inward eye,—who does not love to shuffle off time and its concerns, at intervals, — to forget who is President and who is Governor, what race he belongs to, what language he speaks, which golden-headed nail of the firmament his particular planetary system is hung upon, and listen to the great liquid metronome as it beats its solemn measure, steadily swinging when the solo or duet of human life began, and to swing just as steadily after the human chorus has died out and man is a fossil on its shores?

OLIVER WENDELL HOLMES

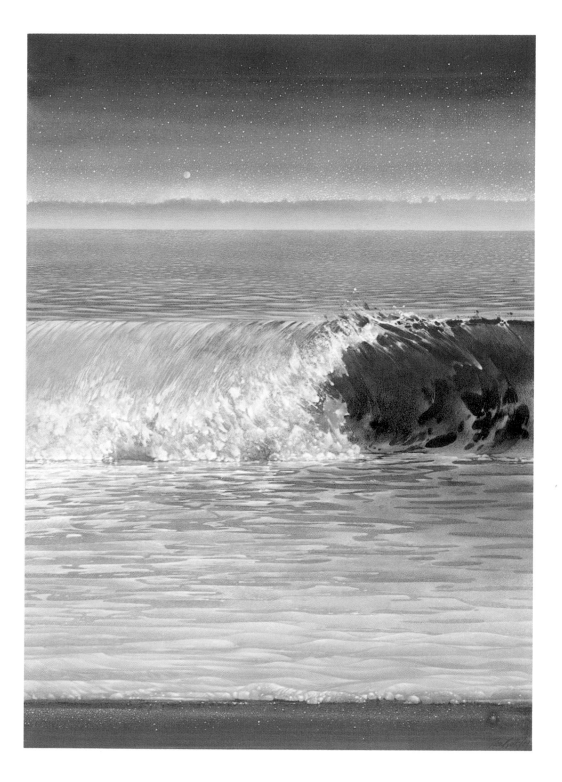

FOR MIRIAM *The sea is awash with roses O they blow*
Upon the land

The still hills fill with their scent
O the hills flow on their sweetness
As on God's hand

O love, it is so little we know of pleasure
Pleasure that lasts as the snow

But the sea is awash with roses O they blow
Upon the land

KENNETH PATCHEN

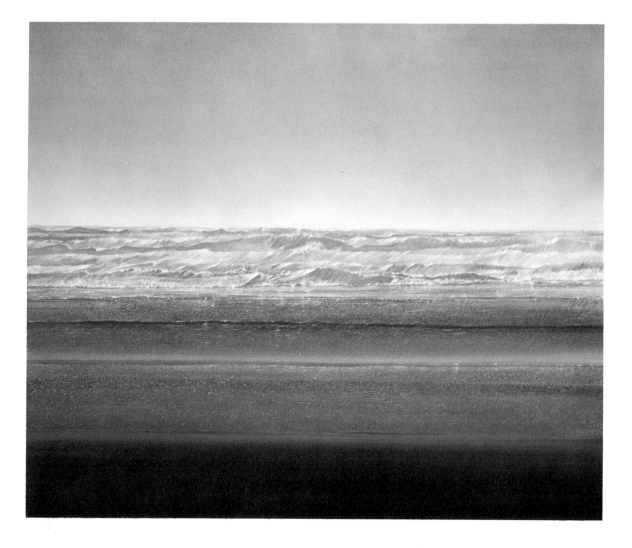

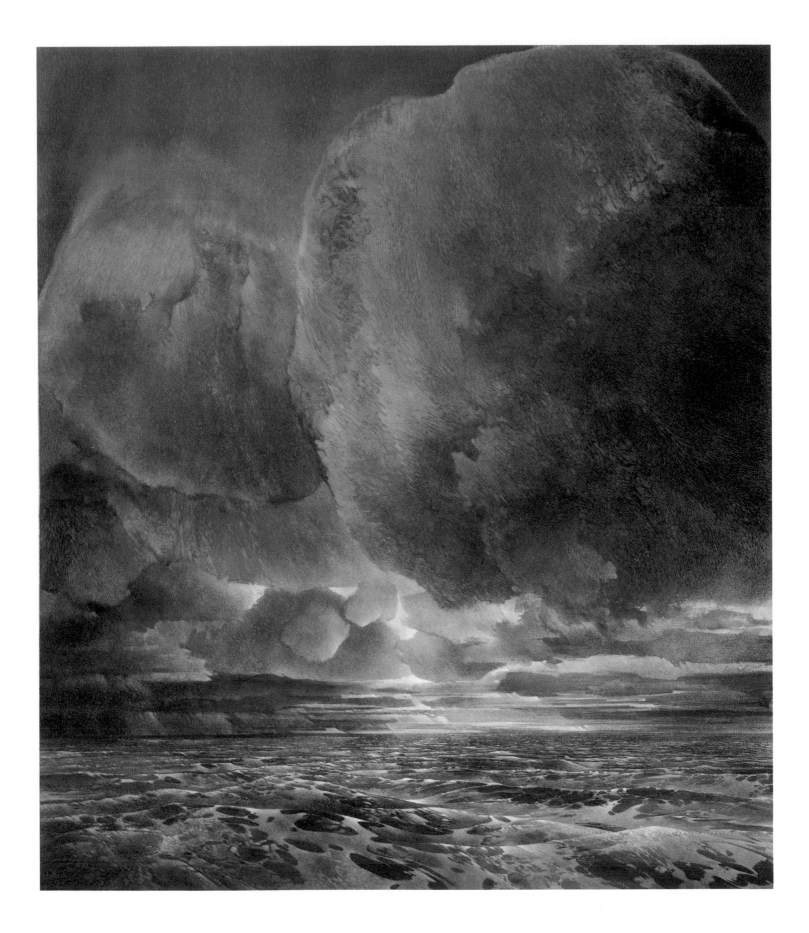

CARIBBE NIGHTS

Sometimes again, there were simply long bands of clouds traversing the sky, gold overlying gold; — the clouds themselves being of a clear, incandescent gold, against a background of dead and tarnished Byzantine gold. Below the sea would take a singular shade of peacock-blue, with gleams as of hot metal. Then all this would pass away, would extinguish itself in deep limpidities, in shadowy colors for which no name can be found.

And the nights which came after! The very nights were luminous. When everything slumbered in heavy immobility, in dead silence, the stars above appeared more dazzling than in any other region of the globe.

And the sea also glowed from below. There was a sort of vast gleam diffused through the waters. The faintest movements, — that of the ship in her sluggish course, — that of the shark turning in our wake, — created glow-worm-colored lights in the warm eddies. And then, over the great phosphorescent mirror of the sea, thousands of wildfires were playing, — as if little lamps, mysterious little lamps, were everywhere lighting themselves to burn a few seconds, and then die down. Those nights were faint with heat, full of phosphorus; and all that extinguished Immensity was hatching light; and all those waters enclosed latent life in rudimentary form, — even as did, of old, the gloomy waters of the primitive world.

PIERRE LOTI

IN THE HEART OF MAN, SOLITUDE. Strange the man, shoreless, near the woman, herself a shore. And myself a sea at your orient, as if mingled with your golden sand, may I go once more and linger on your shore, in the slow unrolling of your coils of clay—woman who forms and unforms with the wave that engenders her.

And you, more chaste for being more naked, clothed by your hands alone, you are no Virgin raised from the depths, Victory of bronze or white stone recovered, with the amphora, in the great meshes laden with seaweed by the workers; but woman's flesh before my face, woman's warmth in my nostrils, and woman's whole radiance, her aroma, like the rose flame of fire between half-joined fingers.

And as salt is in the wheat, the sea in you in its essence, the thing in you which was of the sea, has given you that taste of a happy woman to whom I come... And your face is upturned, your mouth is fruit to be consumed, in the hull of the bark, in the night. Free my breath on your throat, and from everywhere the rising of seas of desire, as in the full tides of the closest moon, when the female land opens to the salacious, supple sea, adorned with bubbles even in its ponds, its maremmas, and the sea high in the grass makes the sound of a noria, the night bursts with sea-hatchings...

ST. JOHN PERSE

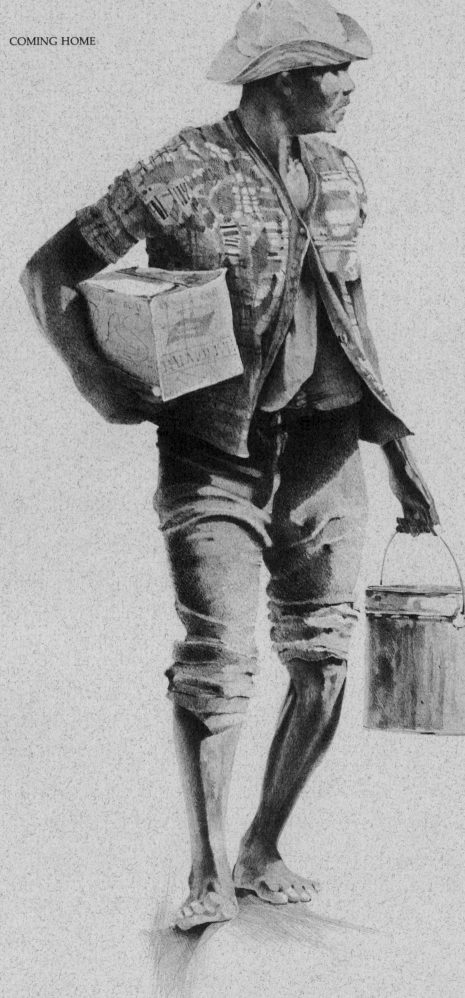

HYMN TO THE SEA

Like all who live on small islands
I must always be remembering the sea,
Being always cognizant of her presence; viewing
Her through apertures in the foliage; hearing,
When the wind is from the south, her music, and smelling
The warm rankness of her; tasting
And feeling her kisses on bright sunbathed days:
I must always be remembering the sea.

Always, always the encircling sea,
Eternal: lazylapping, crisscrossed with stillness;
Or windruffed, aglitter with gold; and the surf
Waist-high for children, or horses for Titans;
Her lullaby, her singing, her moaning; on sand,
On shingle, on breakwater, and on rock;
By sunlight, starlight, moonlight, darkness:
I must always be remembering the sea.

Go down to the sea upon this random day
By metalled road, by sandway, by rockpath,
And come to her. Upon the polished jetsam,
Shell and stone and weed and saltfruit
Torn from the underwater continents, cast
Your garments and despondencies; re-enter
Her embracing womb: a return, a completion.
I must always be remembering the sea.

Life came from the sea, and once a goddess arose
Fullgrown from the saltdeep; love
Flows from the sea, a flood; and the food
Of islanders is reaped from the sea's harvest.

And not only life and sustenance; visions, too,
Are born of the sea: the patterning of her rhythm
Finds echoes within the musing mind.
I must always be remembering the sea.

Symbol of fruitfulness, symbol of barrenness,
Mother and destroyer, the calm and the storm!
Life and desire and dreams and death
Are born of the sea; this swarming land
Her creation, her signature set upon the salt ooze
To blossom into life; and the red hibiscus
And the red roofs burn more brightly against her blue.
I must always be remembering the sea.

FRANK COLLYMORE

CHAOTIC EPIC

Lonely fisherman
Casting his net into shallow seas
Sings a song
As beautiful as sons of the wind,
Black fisherman,
Bound to eternities of squalor
Becomes a moving silhouette

A fleck of shadow
A song and a cadence of laughter with the wind.

And seagulls on the wing
Swoop down to kiss foam crested waves
and flecked with salted spume
Vanish with rushing tides of wind
Beyond the arm of land
And jagged wound of tangled trees.
Echoes of sharp and broken cries
Are all they leave to greet
New flowing tides of wind,
New arriving flocks of birds,
Black fishermen
And crude rock fisted arm of land.

JAN CAREW

SEEDS OF THE POMEGRANATE

There is no forgetting the islands, I said.

Another had seen the fishermen
Diving for sea-eggs, far-out, between
The reefs; and watched their women
Sitting cross-legged on shore, fasten
The leaves of sea-grape into cones,
Filled with the orange flesh.

There is no forgetting the islands, I said.
Where the sun has left no shadows.

The arum grows wild—a third remembered—
Up on the mountains: And night-blue
Emperors steal its pollen.
I could have crushed their azure bodies
Against my face and sold their wings
To swarthy merchant-smiths.

There is no forgetting the islands, I said,
Where the sun has left no shadows.
They will fill your eyes with richness

Like sun-flowers fixed in the dark
Of waning moons, they said, we have watched
The evening climb from Teneriffe.
And in the hills behind
The villagers put by their potter's wheels
And washed the red clay from their hands.

There is no forgetting the islands, I said,
Where the sun has left no shadows.
They will fill your eyes with richness
Till they have made you blind.

One said—I have pulled the cactus
When it flowered at full moon;
And in the dark it shone like moonlight.
I played my music with the cactus'
Needles, till the lizards froze,
Making an emerald stillness.

There is no forgetting the islands, I said,
Where the sun has left no shadows.
They will fill your eyes with richness,
Till they have made you blind;
And on your lips will crush bright poisons.

The cocoa-pods—another spoke—
Are coloured like their leaves; the water
Purple and red reflection.
And I have curved my hands around
The coconuts a Negress brought
To drink from the fruit's green bowl.

There is no forgetting the islands, I said,
Where the sun has left no shadows.
They will fill your eyes with richness
Till they have made you blind;
And on your lips will crush bright poisons
That steal the senses, leaving sound.

GEOFFREY DRAYTON

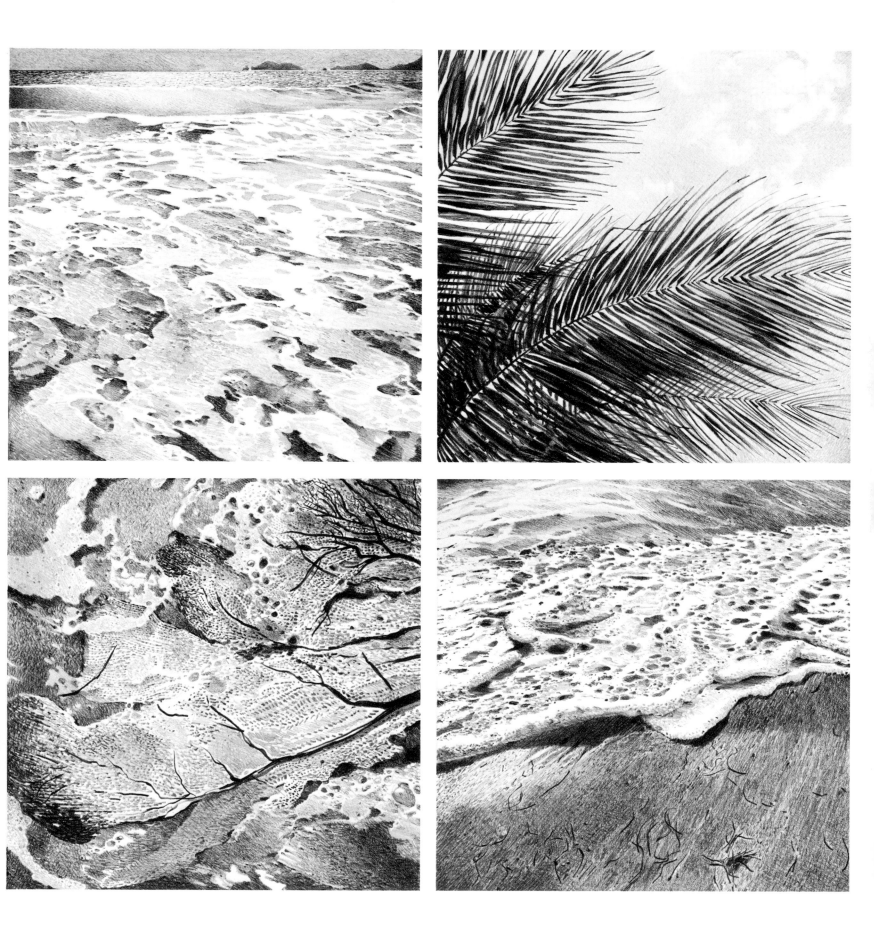

THE GREAT BIRDS

A gentle wind blows in from the water.
Along the banks great birds are majestically striding.
It is morning!

Far out there are boats. Far, far out on that crumbling blue
shelf... toy swans slowly, slowly moving their honey-clotted
wings. It is morning. Morning... and as every morning is, it is
unstained, now...

exactly like the very first morning ever to come to this world.

O the sparkling land, the sea, the heavens!
O hushed and clean in the wonder of it!
As slowly, slowly now the great birds appear... wheeling up,
up, up! And at last they are above the village, above the
golden-pink blur of houses and bridges—

with our two hearts caught in the lift of their great wings.

And now the boats... nearer, nearer they come! At last we can
see the tumbling glitter of fish on their decks. And yes, one of
the fishermen has glimpsed us—he waves, calls a greeting, as
above him wheel the birds in giant spirals. Ah! suddenly one
dives, then another, and another—

their wings brush across the water like fingers of a caressing hand.

A strand of your hair touches my cheek.

How much better for the world
had nothing else ever happened in it.

KENNETH PATCHEN

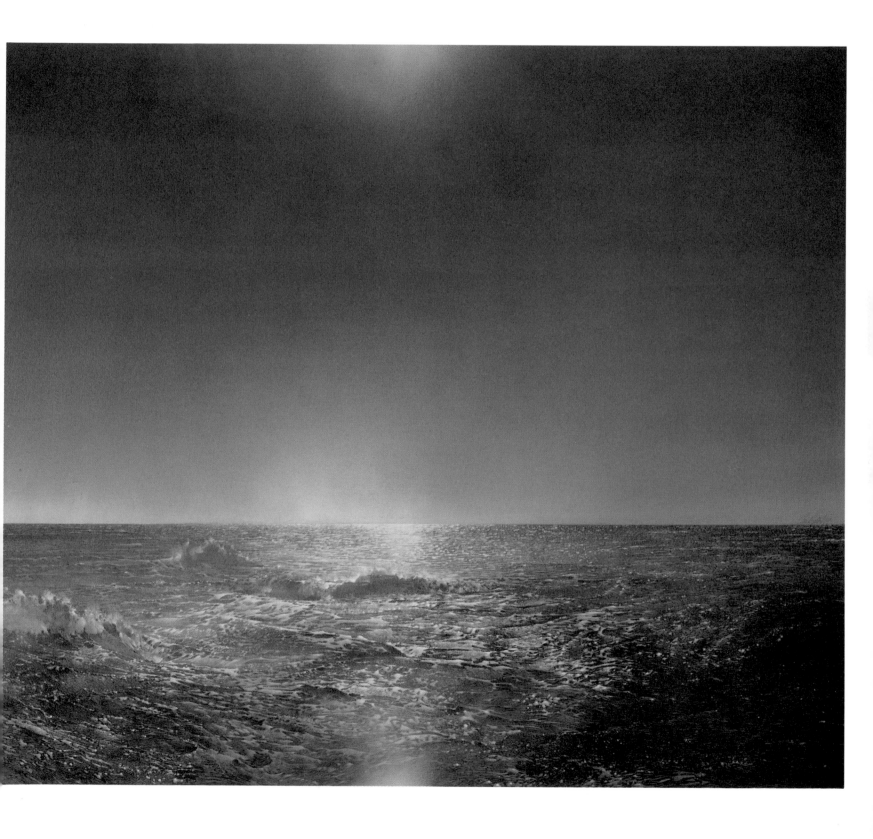

FIRST MORNING

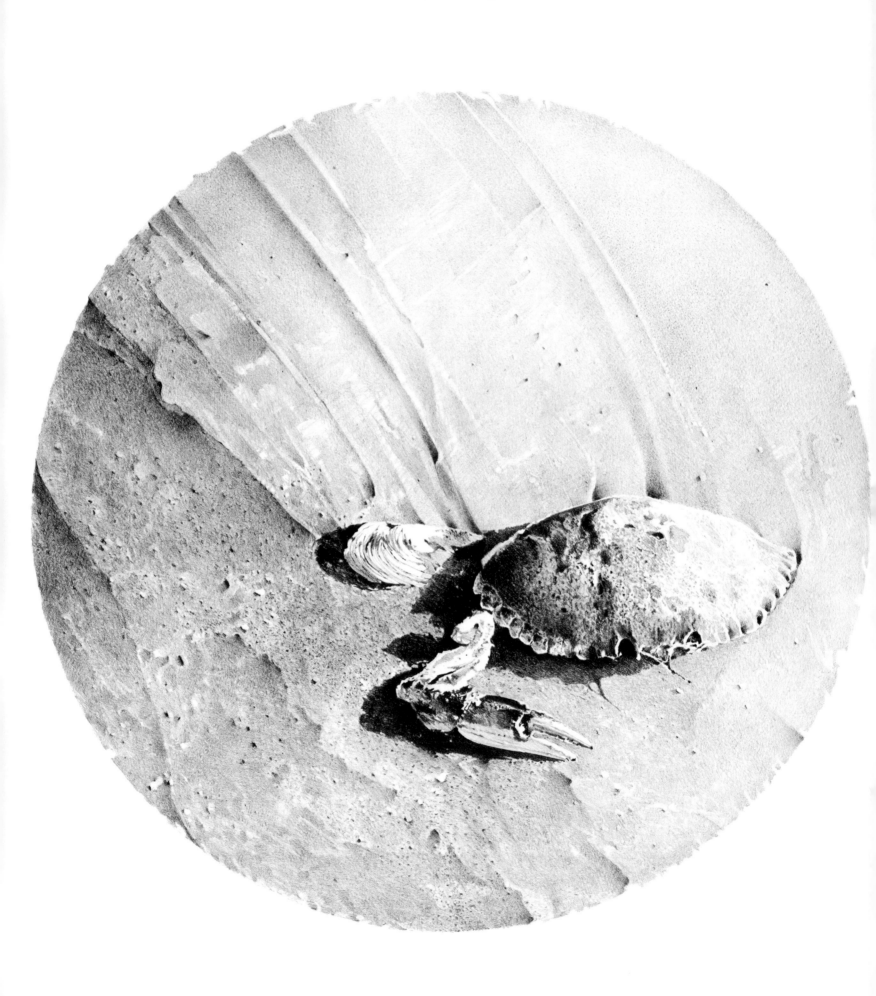

THE CRAB THAT PLAYED WITH THE SEA

Then the Eldest Magician slid his arm up to the shoulder through the deep warm water, and under the roots of the Wonderful Tree he touched the broad back of Pau Amma the Crab. And Pau Amma settled down at the touch, and all the Sea rose up as water rises in a basin when you put your hand into it.

'Ah!' said the Eldest Magician. 'Now I know who has been playing with the Sea'; and he called out, 'What are you doing, Pau Amma?'

And Pau Amma, deep down below, answered, 'Once a day and once a night I go out to look for my food. Once a day and once a night I return. Leave me alone.'

Then the Eldest Magician said, 'Listen, Pau Amma. When you go out from your cave the waters of the Sea pour down into Pusat Tasek, and all the beaches of all the islands are left bare, and the little fish die, and Rajah Moyang Kaban, the King of the Elephants, his legs are made muddy. When you come back and sit in Pusat Tasek, the waters of the Sea rise, and half the little islands are drowned, and the Man's house is flooded, and Rajah Abdullah, the King of the Crocodiles, his mouth is filled with the salt water.'

Then Pau Amma, deep down below, laughed and said, 'I did not know I was so important. Henceforward I will go out seven times a day, and the waters shall never be still.'

And the Eldest Magician said, 'I cannot make you play the play you were meant to play, Pau Amma, because you escaped me at the Very Beginning; but if you are not afraid, come up and we will talk about it.'

'I am not afraid,' said Pau Amma, and he rose to the top of the sea in the moonlight. There was nobody in the world so big as Pau Amma—for he was the King Crab of all Crabs. Not a common Crab, but a King Crab. One side of his great shell touched the beach at Sarawak; the other touched the beach at Pahang; and he was taller than the smoke of three volcanoes! As he rose up through the branches of the Wonderful Tree he tore off one of the great twin-fruits —the magic double-kernelled nuts that make people young, — and the little girl-daughter saw it bobbing alongside the canoe, and pulled it in and began to pick out the soft eyes of it with her little golden scissors.

'Now,' said the Magician, 'make a Magic, Pau Amma, to show that you are really important.'

Pau Amma rolled his eyes and waved his legs, but he could only stir up the Sea, because, though he was a King Crab, he was nothing more than a Crab, and the Eldest Magician laughed.

'You are not so important after all, Pau Amma,' he said 'Now, let *me* try,' and he made a Magic with his left hand — with just the little finger of his left hand — and — lo and behold, Best Beloved, Pau Amma's hard, blue-green-black shell fell off him as a husk falls off a coconut, and Pau Amma was left all soft — soft as the little crabs that you sometimes find on the beach, Best Beloved.

'Indeed, you are very important,' said the Eldest Magician. 'Shall I ask the Man here to cut you with his *kris?* Shall I send for Rajah Moyang Kaban, the King of the Elephants, to pierce you with his tusks? Or shall I call Rajah Abdullah, the King of the Crocodiles, to bite you?'

And Pau Amma said, 'I am ashamed! Give me back my hard shell and let me go back to Pusat Tasek, and I will only stir out once a day and once a night to get my food.'

And the Eldest Magician said, 'No, Pau Amma, I will *not* give you back your shell, for you will grow bigger and prouder and stronger, and perhaps you will forget your promise, and you will play with the Sea once more.'

Then Pau Amma said, 'What shall I do? I am so big that I can only hide in Pusat Tasek, and if I go anywhere else, all soft as I am now, the sharks and the dogfish will eat me. And if I go to Pusat Tasek, all soft as I am now, though I may be safe, I can never stir out to get my food, and so I shall die.' Then he waved his legs and lamented.

'Listen, Pau Amma,' said the Eldest Magician. 'I cannot make you play the play you were meant to play, because you escaped me at the Very Beginning; but if you choose, I can make every stone and every hole and every bunch of weed in all the seas a safe Pusat Tasek for you and your children for always.'

Then Pau Amma said, 'That is good, but I do not choose yet. Look! there is that Man who talked to you at the Very Beginning. If he had not taken up your attention I should not have grown tired of waiting and run away, and all this would never have happened. What will *he* do for me?'

And the Man said, 'If you choose, I will make a Magic, so that both the deep water and the dry ground will be a home for you and your children — so that you shall be able to hide both on the land and in the sea.'

And Pau Amma said, 'I do not choose yet. Look! there is

that girl who saw me running away at the Very Beginning. If she had spoken then, the Eldest Magician would have called me back, and all this would never have happened. What will *she* do for me?'

And the little girl-daughter said, 'This is a good nut that I am eating. If you choose, I will make a Magic and I will give you this pair of scissors, very sharp and strong, so that you and your children can eat coconuts like this all day long when you come up from the Sea to the land; or you can dig a Pusat Tasek for yourself with the scissors that belong to you when there is no stone or hole near by; and when the earth is too hard, by the help of these same scissors you can run up a tree.'

And Pau Amma said, 'I do not choose yet, for, all soft as I am, these gifts would not help me. Give me back my shell, O Eldest Magician, and then I will play your play.'

And the Eldest Magician said, 'I will give it back, Pau Amma, for eleven months of the year; but on the twelfth month of every year it shall grow soft again, to remind you and all your children that I can make Magics, and to keep you humble, Pau Amma; for I see that if you can run both under the water and on land, you will grow too bold; and if you can climb trees and crack nuts and dig holes with your scissors, you will grow too greedy, Pau Amma.'

Then Pau Amma thought a little and said, 'I have made my choice. I will take all the gifts.'

Then the Eldest Magician made a Magic with the right hand, with all five fingers of his right hand, and lo and behold, Best Beloved, Pau Amma grew smaller and smaller and smaller, till at last there was only a little green crab swimming in the water alongside the canoe, crying in a very small voice, 'Give me the scissors!'

And the girl-daughter picked him up on the palm of her little brown hand, and sat him in the bottom of the canoe and gave him her scissors, and he waved them in his little arms, and opened them and shut them and snapped them, and said, 'I can eat nuts. I can crack shells. I can dig holes. I can climb trees. I can breathe in the dry air, and I can find a safe Pusat Tasek under every stone. I did not know I was so important. *Kun?*' (Is this right?)

'*Payak kun*,' said the Eldest Magician, and he laughed and gave him his blessing; and little Pau Amma scuttled over the side of the canoe into the water; and he was so tiny that he could have hidden under the shadow of a dry leaf on land or of a dead shell at the bottom of the sea.

RUDYARD KIPLING

SEA-DRIFT

Once Paumanok,
When the lilac-scent was in the air and Fifth-month
 grass was growing,

Up this seashore in some briers,
Two feather'd guests from Alabama, two together,
And their nest, and four light-green eggs spotted with brown,
And every day the he-bird to and fro near at hand,
And every day the she-bird crouch'd on her nest, silent,
 with bright eyes,
And every day I, a curious boy, never too close,
 never disturbing them,
Cautiously peering, absorbing, translating.

Shine! shine! shine!
Pour down your warmth, great sun!
While we bask, we two together.

Two together!
Winds blow south, or winds blow north,
Day come white, or night come black,
Home or rivers and mountains from home,
Singing all time, minding no time,
While we two keep together.

Till of a sudden,
May-be kill'd, unknown to her mate,
One forenoon the she-bird crouch'd not on the nest,
Nor return'd that afternoon, nor the next,
Nor ever appear'd again.

And thenceforward all summer in the sound of the sea,
And at night under the full of the moon in calmer weather,
Over the hoarse surging of the sea,
Or flitting from brier to brier by day,
I saw, I heard at intervals the remaining one, the he-bird,
The solitary guest from Alabama.

Blow! blow! blow!
Blow up sea-winds along Paumanok's shore;
I wait and I wait till you blow my mate to me.

Yes, when the stars glisten'd,
All night long on the prong of a moss-scallop'd stake,
Down almost amid the slapping waves,
Sat the lone singer wonderful causing tears.

He call'd on his mate,
He pour'd forth the meanings which I of all men know.

Yes my brother I know,
The rest might not, but I have treasur'd every note,
For more than once dimly down to the beach gliding,
Silent, avoiding the moonbeams, blending myself
 with the shadows,
Recalling now the obscure shapes, the echoes, the sounds
 and sights after their sorts,
The white arms out in the breakers tirelessly tossing,
I, with bare feet, a child, the wind wafting my hair,
Listen'd along and long.

Listen'd to keep, to sing, now translating the notes,
Following you my brother.

Soothe! soothe! soothe!
Close on its wave soothes the wave behind,
And again another behind embracing and lapping, every one close,
But my love soothes not me, not me.

Low hangs the moon, it rose late,
It is lagging—O I think it is heavy with love, with love.

O madly the sea pushes upon the land,
With love, with love.

O night! do I not see my love fluttering out
 among the breakers?
What is that little black thing I see there in the white?

Loud! loud! loud!
Loud I call to you, my love!
High and clear I shoot my voice over the waves,
Surely you must know who is here, is here,
You must know who I am, my love.
Low-hanging moon!
What is that dusky spot in your brown yellow?
O it is the shape, the shape of my mate!
O moon do not keep her from me any longer.

GULLCRASH

47

Land! land! O land!
Whichever way I turn, O I think you could give me my mate
 back again if you only would,
For I am almost sure I see her dimly whichever way I look.

O rising stars!
Perhaps the one I want so much will rise, will rise with
 some of you.

O throat! O trembling throat!
Sound clearer through the atmosphere!
Pierce the woods, the earth,
Somewhere listening to catch you must be the one I want.

Shake out carols!
Solitary here, the night's carols!
Carols of lonesome love! death's carols!
Carols under that lagging, yellow, waning moon!
O under that moon where she droops almost down into the sea!
O reckless despairing carols.

But soft! sink low!
Soft! let me just murmur,
And do you wait a moment you husky-nois'd sea,
For somewhere I believe I heard my mate responding to me,
So faint, I must be still, be still to listen,
But not altogether still, for then she might not come
 immediately to me.

Hither my love!
Here I am! here!
With this just-sustain'd note I announce myself to you,
This gentle call is for my love, for you.

Do not be decoy'd elsewhere,
That is the whistle of the wind, it is not my voice,
That is the fluttering, the fluttering of the spray,
Those are the shadows of leaves.

O darkness! O in vain!
O I am very sick and sorrowful.

O brown halo in the sky near the moon, drooping upon the sea!
O troubled reflection in the sea!
O throat! O throbbing heart!
And I singing uselessly, uselessly all the night.

O past! O happy life! O songs of joy!
In the air, in the woods, over fields,
Loved! loved! loved! loved! loved!
But my mate no more, no more with me!
We two together no more.

The aria sinking,
All else continuing, the stars shining,
The winds blowing, the notes of the bird
 continuously echoing,
With angry moans the fierce old mother
 incessantly moaning,
On the sands of Paumanok's shore gray and rustling,

The yellow half-moon enlarged, sagging down, drooping,
 the face of the sea almost touching,
The boy ecstatic, with his bare feet the waves, with his hair
 the atmosphere dallying,
The love in the heart long pent, now loose, now at last
 tumultuously bursting,
The aria's meaning, the ears, the soul, swiftly depositing,
The strange tears down the cheeks coursing,
The colloquy there, the trio, each uttering,
The undertone, the savage old mother incessantly crying,
To the boy's soul's questions sullenly timing,
 some drown'd secret hissing,
To the outsetting bard.

Demon or bird! (said the boy's soul,)
Is it indeed toward your mate you sing? or is it really to me?
For I, that was a child, my tongue's use sleeping, now
 I have heard you,
Now in a moment I know what I am for, I awake.

And already a thousand singers, a thousand songs, clearer,
 louder and more sorrowful than yours,
A thousand warbling echoes have started to life within me,
 never to die.

O you singer solitary, singing by yourself, projecting me,
O solitary me listening, never more shall I cease perpetuating you,
Never more shall I escape, never more than reverberations,
Never more the cries of unsatisfied love be absent from me,
Never again leave me to be the peaceful child I was before what
 there in the night,
By the sea under the yellow and sagging moon,
The messenger there arous'd, the fire, the sweet hell within,
The unknown want, the destiny of me.

O give me the clew! (it lurks in the night here somewhere,)
O if I am to have so much, let me have more!

A word then, (for I will conquer it,)
The word final, superior to all,
Subtle, sent up—what is it?—I listen;
Are you whispering it, and have been all the time, you sea waves?
Is that it from your liquid rims and wet sands?

Whereto answering, the sea,
Delaying not, hurrying not,
Whisper'd me through the night, and very plainly before daybreak
Lisp'd to me the low and delicious word death,
And again death, death, death, death,
Hissing melodious, neither like the bird nor like my
 arous'd child's heart,
But edging near as privately for me rustling at my feet,
Creeping thence steadily up to my ears and laving me softly all ove
Death, death, death, death, death.

Which I do not forget,
But fuse the song of my dusky demon and brother,

That he sang to me in the moonlight on Paumanok's gray beach,
With the thousand responsive songs at random,
My own songs awaked from that hour,
And with them the key, the word up from the waves,
The word of the sweetest song and all songs,
That strong and delicious word which, creeping to my feet,
(Or like some old crone rocking the cradle, swathed in
 sweet garments, bending aside,)
The sea whisper'd me. WALT WHITMAN

48

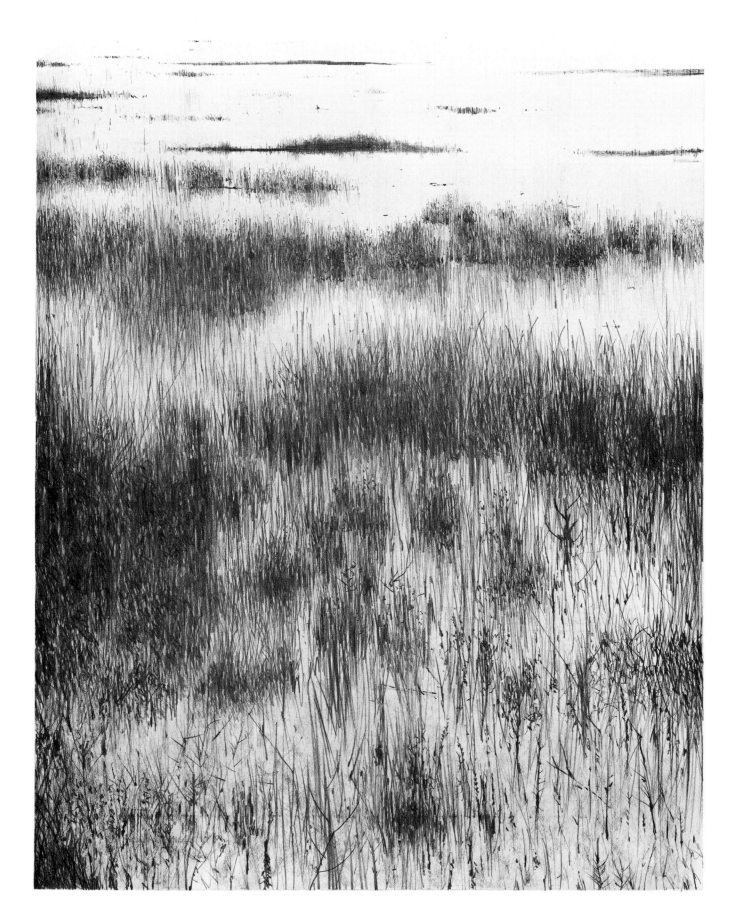

FROM THE SEA TO CHILDREN

The sea—a soaring mountain—
Lashes and crushes mighty cliffs of rock.
Those flimsy things, what are they to me?
"Know ye my power?" The sea lashes
Threateningly, it breaks, it crushes.

No fear assaults, no terror
Masters me. Earth's power and pride
Are tedious toys to me. All that the earth
Imagines mighty is to me no more
Than a mere feather floating by.

Who has not bowed his head
Before my sovereignty, let him come forth.
Princes of earth, challenge me if you will.
First Emperor, Napoleon, are you my adversary?
Come, come then, compete with me.

Perched on a small hill or possessed
Of an islet or a patch of land,
Thinking that you alone reign supreme
In that kingdom small as a grain,
Approach me, coward, gaze on me.

Only the arching vault of sky, my kin,
Can equal me, only the vast sky,
Whose bright image my waters beat.
Free from sin, free from stain
It ignores earth's little multitudes.

I scorn the world's madness,
The overweaning men who seek to use me.
My love (brave children)—that is given
Only to those who come to me with love.
Come, children, let me kiss you and embrace you.

CH'OE NAM-SON

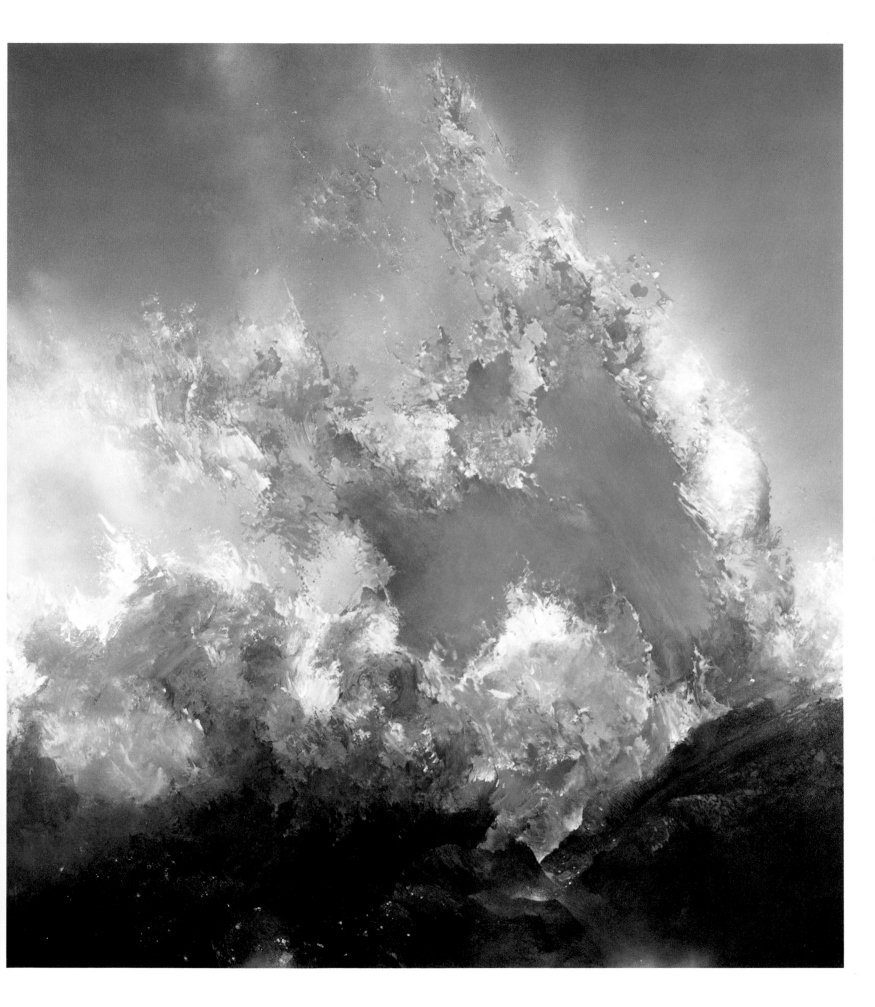

THE SEA

*Running out
crying
laughing
whirling my arms
kicking back sand
a domesticated
little being
to wild nature
the sea
returns.*

SABURO KURODA

SEA

The sea, that once was God's belonging,
Thereafter came to be
Possessed by brave explorers
And, thanks to them, the sea
Fell to the ownership of earth
And thus it was possessed
By small boys dreaming on the beach
Of the wide world at its best.
The sea was once King Neptune's realm
And once it was a green
Home for lonely buccaneers;
But the sea has never been
A property of nations,
Nor shall the sea belong
To such faint hearts as scare themselves
Lest anything go wrong.

TANIKAWA SHUNTARO

TO A CHILD DANCING IN THE WIND

Dance there upon the shore;
What need have you to care
For wind or water's roar?
And tumble out your hair
That the salt drops have wet;
Being young you have not known
The fool's triumph, nor yet
Love lost as soon as won,
Nor the best labourer dead
And all the sheaves to bind.
What need have you to dread
The monstrous crying of wind?

TWO YEARS LATER

Has no one said those daring
Kind eyes should be more learn'd?
Or warned you how despairing
The moths are when they are burned?
I could have warned you; but you are young,
So we speak a different tongue.

O you will take whatever's offered
And dream that all the world's a friend,
Suffer as your mother suffered,
Be as broken in the end;
But I am old and you are young,
And I speak a barbarous tongue.

WILLIAM BUTLER YEATS

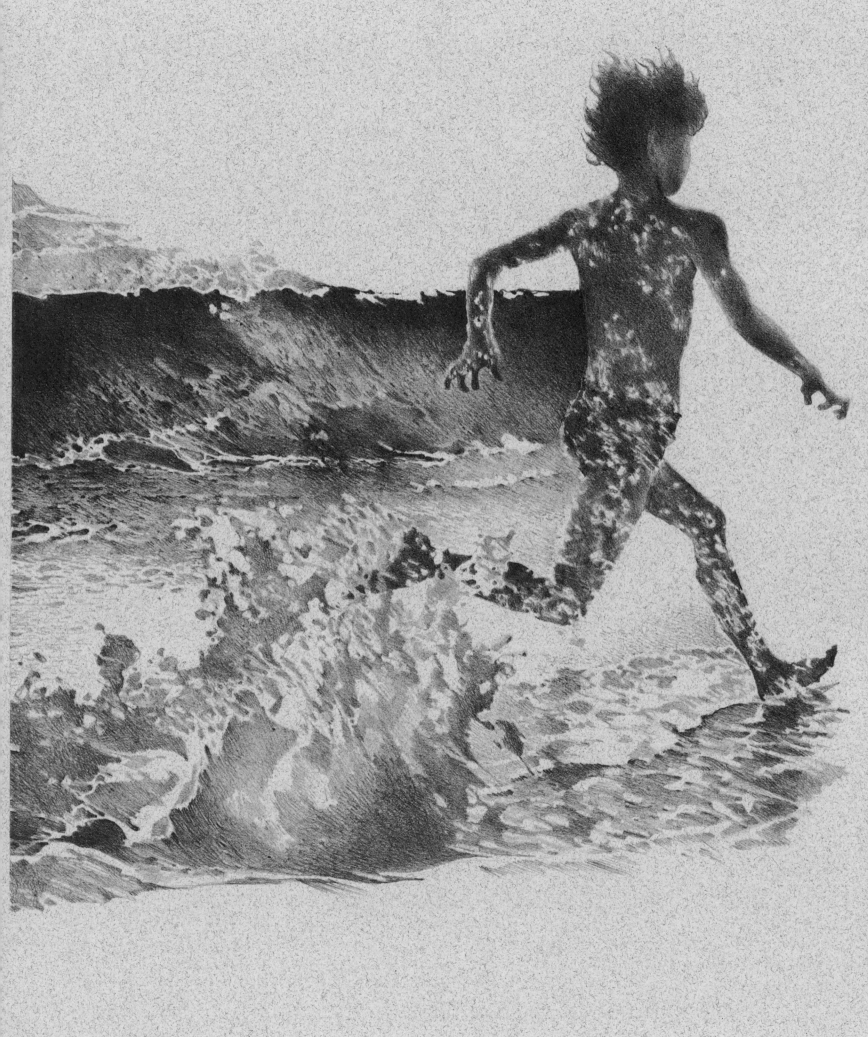

THE ISLAND

If I had a ship,
I'd sail my ship,
I'd sail my ship
Through Eastern seas;
Down to a beach where the slow waves thunder—
The green curls over and the white falls under—
Boom! Boom! Boom!
On the sun-bright sand.
Then I'd leave my ship and I'd land,
And climb the steep white sand,

And climb to the trees,
The six dark trees,
The coco-nut trees on the cliff's green crown—
Hands and knees
To the coco-nut trees,
Face to the cliff as the stones patter down,
Up, up, up, staggering, stumbling,
Round the corner where the rock is crumbling
Round this shoulder,
Over this boulder,
Up to the top where the six trees stand . . .

And there would I rest, and lie,
My chin in my hands, and gaze
At the dazzle of sand below,
And the green waves curling slow,
And the grey-blue distant haze
Where the sea goes up to the sky . . .

And I'd say to myself as I looked so lazily down at the sea:
"There's nobody else in the world, and the world was made for me."

A.A. MILNE

EVENING SEA

The sea and the land slip into the vast blue of evening.
The rolling waves on the shore
crawl in the shadow,
fumbling for the last ray of light on the land,
and vainly return
to the dark sea.
The light
is burning faintly,
fringing the silhouette of a headland
as a quiet stream of golden green.
Again, the light
is blooming a splendor of rose
on the clouds around the zenith,
and holding
a moment of fragile solemnity . . .

TOSHIHIKO KATAYAMA

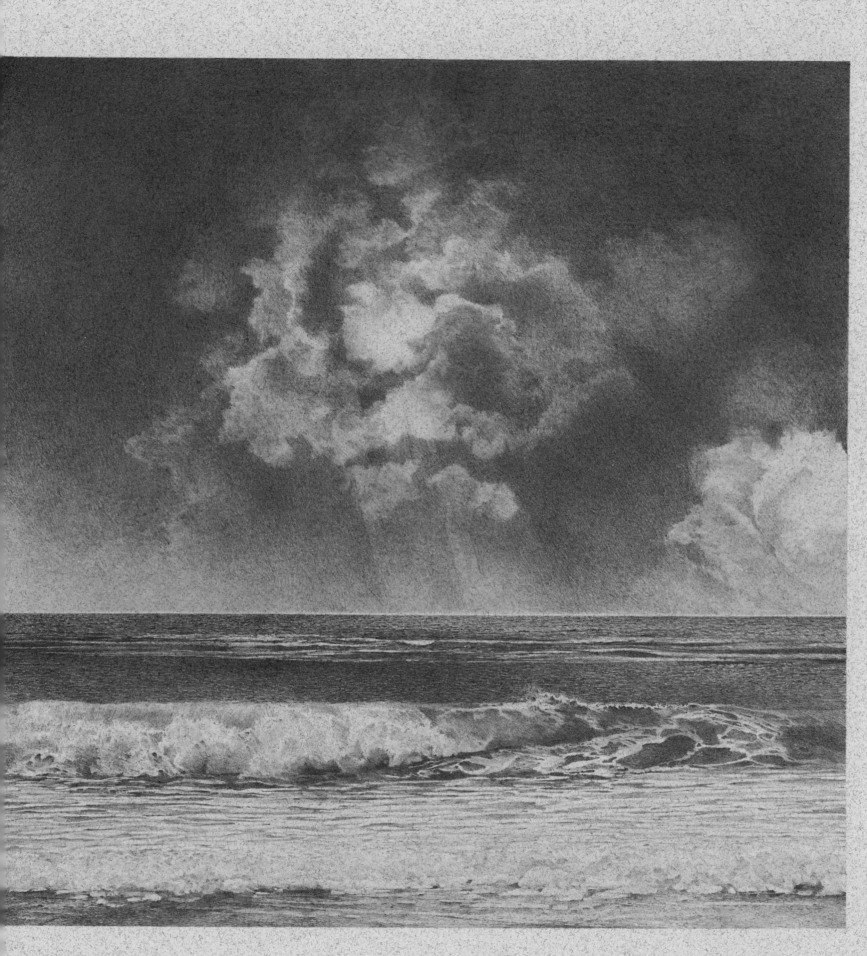

THE SEA

The untamed sea is human
Its emotions erupt in waves.
The sea sends her message of anger
As the waves roll over my head.

SUSAN SHOENBLUM

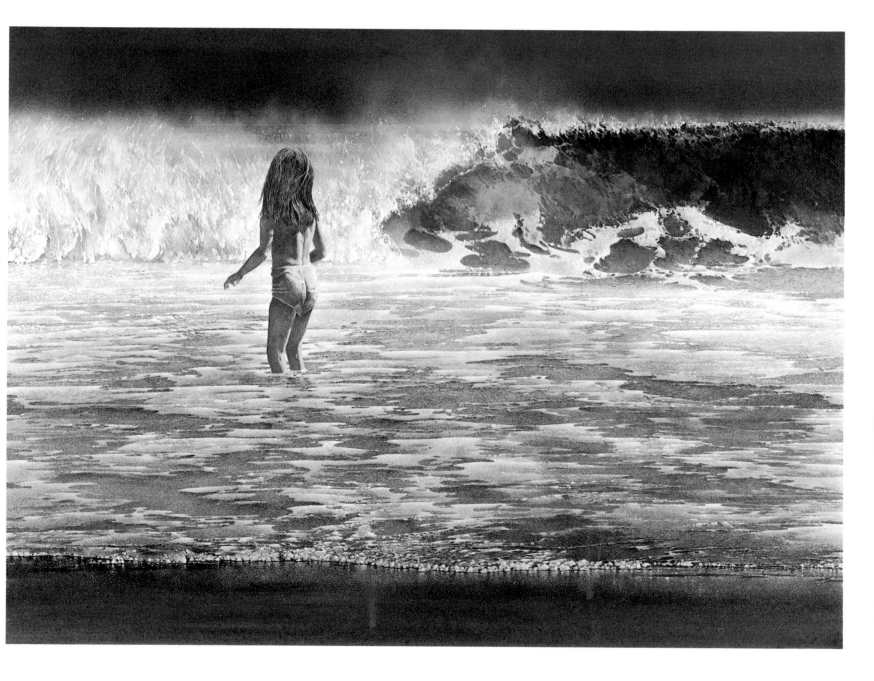

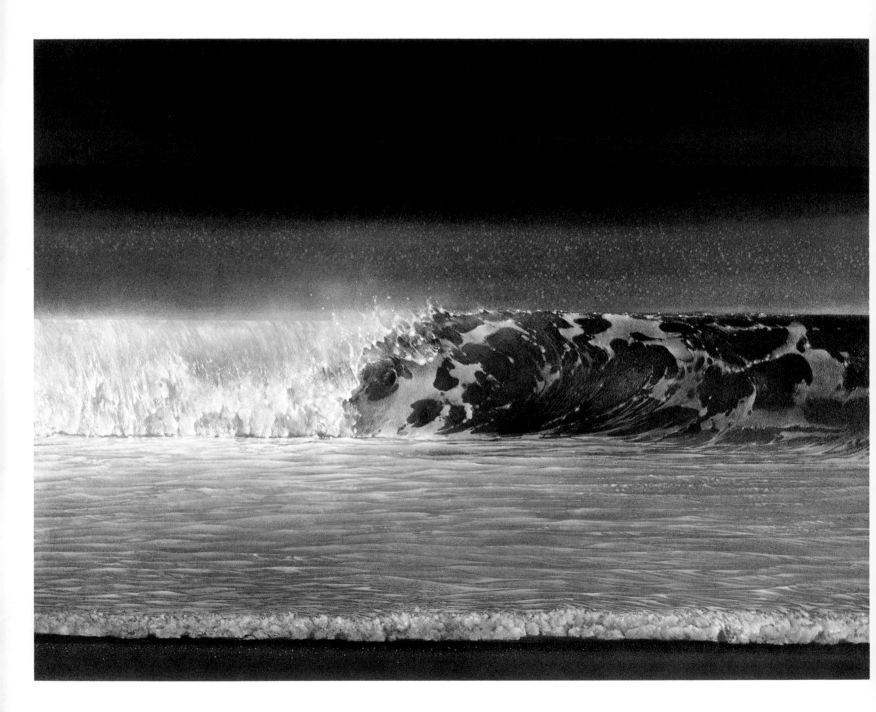

JOHN RUSKIN ON PAINTING THE SEA.

Of all inorganic substances, acting in their own proper nature, and without assistance or combination, water is the most wonderful. If we think of it as the source of all the changefulness and beauty which we have seen in clouds; then as the instrument by which the earth we have contemplated was modelled into symmetry, and its crags chiselled into grace; then as, in the form of snow, it robes the mountains it has made with that transcendent light which we could not have conceived if we had not seen; then as it exists in the foam of the torrent, in the iris which spans it, in the morning mist which rises from it, in the deep crystalline pools which mirror its hanging shore, in the broad lake and glancing river; finally, in that which is to all human minds the best emblem of unwearied unconquerable power, the wild, various, fantastic, tameless unity of the sea; what shall we compare to this mighty, this universal element, for glory and for beauty? Or how shall we follow its eternal changefulness of feeling? It is like trying to paint a soul.

Few people, comparatively, have ever seen the effect on the sea of a powerful gale continued without intermission for three or four days and nights; and to those who have not, I believe it must be unimaginable, not from the mere force or size of surge, but from the complete annihilation of the limit between sea and air. The water from its prolonged agitation is beaten, not into mere creaming foam, but into masses of accumulated yeast, which hang in ropes and wreaths from wave to wave, and, where one curls over to break, form a festoon like a drapery from its edge; these are taken up by the wind, not in dissipating dust, but bodily, in writhing, hanging, coiling masses, which make the air white and thick as with snow, only the flakes are a foot or two long each: the surges themselves are full of foam in their very bodies, underneath, making them white all through, as the water is under a great cataract; and their masses, being thus half water and half air, are torn to pieces by the wind whenever they rise, and carried away in roaring smoke, which chokes and strangles like actual water. Add to this, that when the air has been exhausted of its moisture by long rain, the spray of the sea is caught by it and covers its surface not merely with the smoke of finely divided water, but with boiling mist; imagine also the low rain-clouds brought down to the very level of the sea, as I have often seen them, whirling and flying in rags and fragments from wave to wave; and finally, conceive the surges themselves in their utmost pitch of power, velocity, vastness, and madness, lifting themselves in precipices and peaks, furrowed with their whirl of ascent, through all this chaos; and you will understand that there is indeed no distinction left between the sea and air; that no object, nor horizon, nor any land-mark or natural evidence of position is left; that the heaven is all spray, and the ocean all cloud, and that you can see no farther in any direction than you could see through a cataract.

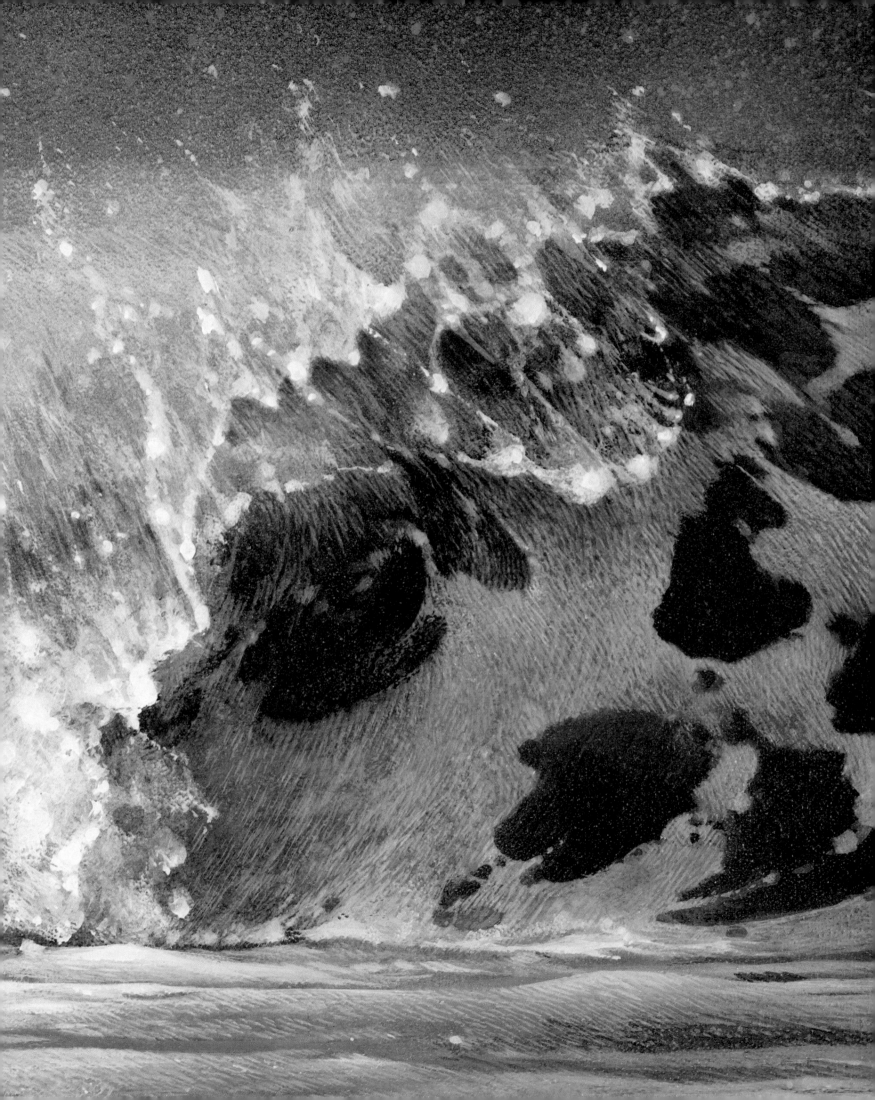

As the right rendering of the Alps depends on power of drawing snow, so the right painting of the sea must depend, at least in all coast scenery, in no small measure on the power of drawing foam. Yet there are two conditions of foam of invariable occurrence on breaking waves, of which I have never seen the slightest record attempted; first, the thick, creamy, curdling, overlapping, massy foam, which remains for a moment only after the fall of the wave, and is seen in perfection in its running up the beach; and, secondly, the thin white coating into which this subsides, which opens into oval gaps and clefts, marbling the waves over their whole surface, and connecting the breakers on a flat shore by long dragging streams of white.

It is evident that the difficulty of expressing either of these two conditions must be immense. The lapping and curdling foam is difficult enought to catch, even when the lines of its undulation alone are considered; but the lips, so to speak, which lie along these lines, are full, projecting, and marked by beautiful light and shade; each has its high light, a gradation into shadow of indescribable delicacy, a bright reflected light, and a dark cast shadow: to draw all this requires labour and care, and firmness of work, which, as I imagine, must always, however skilfully bestowed, destroy all impressions of wildness, accidentalism, and evanescence, and so kill the sea. Again, the openings in the thin subsided foam, in their irregular modifications of circular and oval shapes dragged hither and thither, would be hard enough to draw, even if they could be seen on a flat surface; instead of which, every one of the openings is seen in undulation on a tossing surface, broken up over small surges and ripples, and so thrown into perspectives of the most hopeless intricacy.

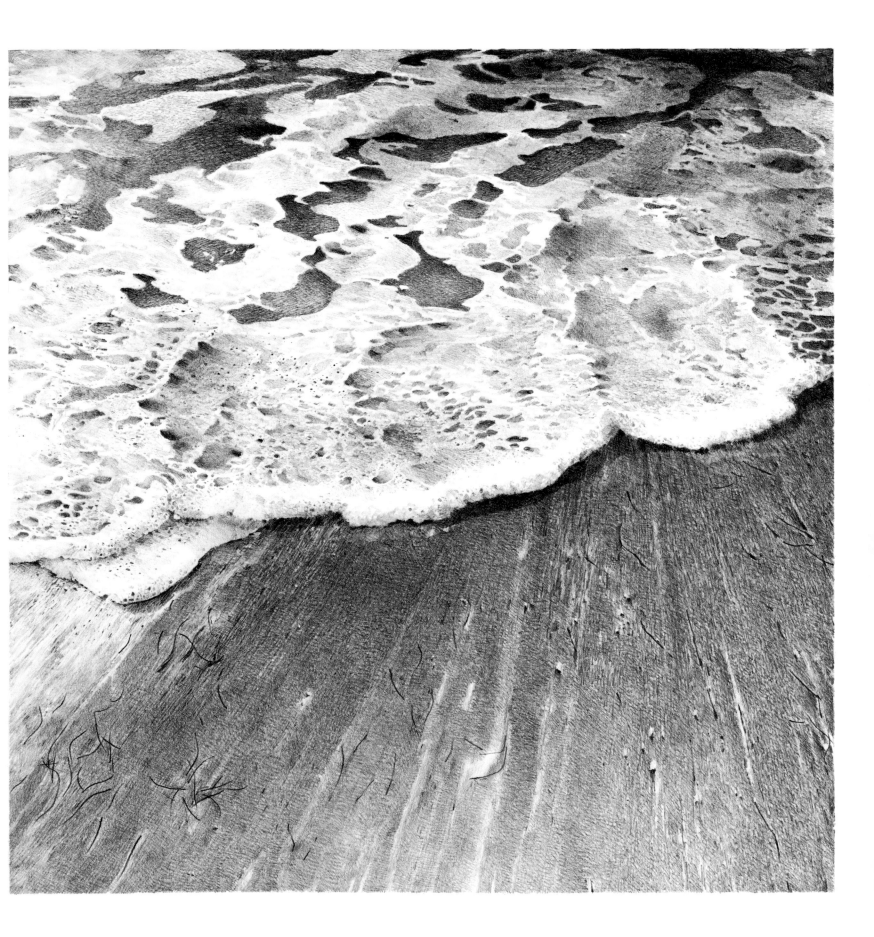

Again, as respects the form of breakers on an even shore, there is difficulty of no less formidable kind. There is in them an irreconcilable mixture of fury and formalism. Their hollow surface is marked by parallel lines, like those of a smooth mill-weir, and graduated by reflected and transmitted lights of the most wonderful intricacy, its curve being at the same time necessarily of mathematical purity and precision; yet at the top of this curve, when it nods over, there is a sudden laxity and giving way, the water swings and jumps along the ridge like a shaken chain, and the motion runs from part to part as it does through a serpent's body. Then the wind is at work on the extreme edge, and instead of letting it fling itself off naturally, it supports it, and drives it back, or scrapes it off, and carries it bodily away; so that the spray at the top is in a continual transition between forms projected by their own weight, and forms blown and carried off with their weight overcome. Then at last, when it has come down, who shall say what shape that may be called, which "shape has none," of the great crash where it touches the beach?

Afloat even twenty yards from the shore, we receive a totally different impression. Every wave around us appears vast, every one different from all the rest; and the breakers present, now that we see them with their backs towards us, the grand, extended, and varied lines of long curvature which are peculiarly expressive both of velocity and power. Recklessness, before unfelt, is manifested in the mad, perpetual, changeful, undirected motion, not of wave after wave, as it appears from the shore, but of the very same water rising and falling. Of waves that successively approach and break, each appears to the mind a separate individual, whose part being performed, it perishes, and is succeeded by another; and there is nothing in this to impress us with the idea of restlessness, any more than in any successive and continuous functions of life and death. But it is when we perceive that it is no succession of wave, but the same water, constantly rising, and crashing, and recoiling, and rolling in again in new forms and with fresh fury, that we perceive the perturbed spirit, and feel the intensity of its unwearied rage. The sensation of power is also trebled; for not only is the vastness of apparent size much increased, but the whole action is different; it is not a passive wave, rolling sleepily forward until it tumbles heavily, prostrated upon the beach; but a sweeping exertion of tremendous and living strength, which does not now appear to *fall*, but to *burst* upon the shore; which never perishes, but recoils and recovers.

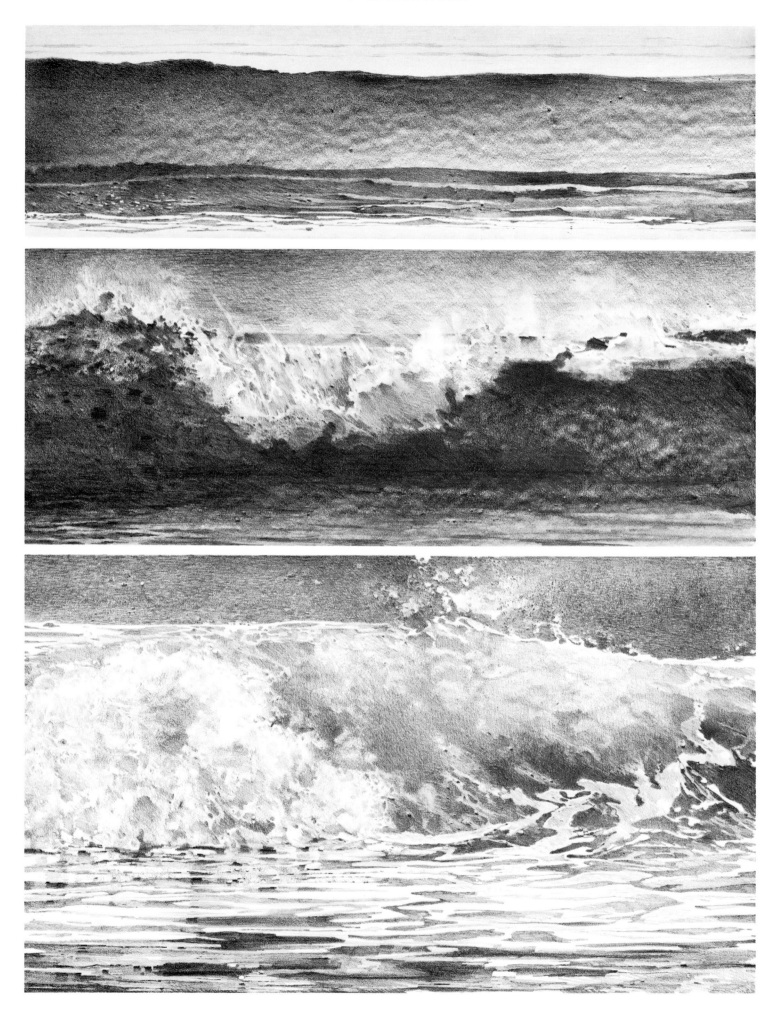

It was his fate, his peculiarity, whether he wished it or not, to come out thus on a spit of land which the sea is slowly eating away, and there to stand, like a desolate sea-bird, alone.

VIRGINIA WOOLF

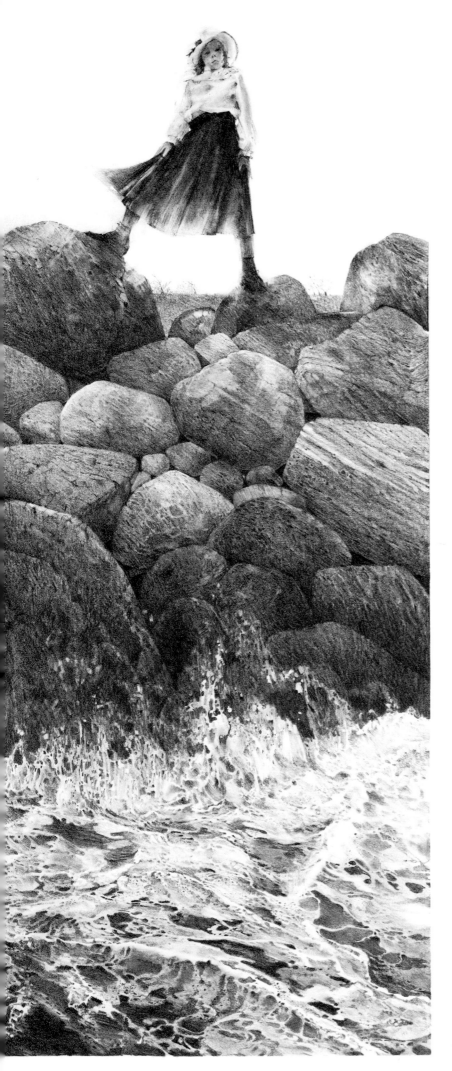

LORELEI

The waves drummed on the shore, like turbaned warriors, like turbaned men with poisoned assegais who, whirling their arms on high, advance upon the feeding flocks, the white sheep.

VIRGINIA WOOLF

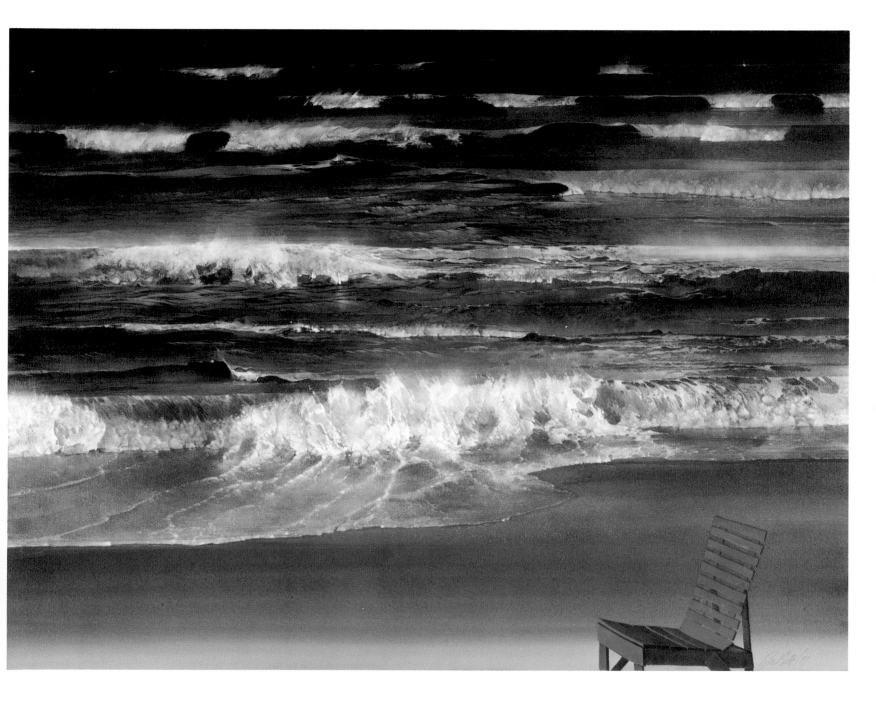

He drank.

"Ah! The good old time—the good old time. Youth and the sea. Glamour and the sea! The good, strong sea, the salt, bitter sea, that could whisper to you and roar at you and knock your breath out of you."

He drank again.

"By all that's wonderful it is the sea, I believe, the sea itself — or is it youth alone? Who can tell? But you here — you all had something out of life: money, love — whatever one gets on shore — and, tell me, wasn't that the best time, that time when we were young at sea; young and had nothing, on the sea that gives nothing, except hard knocks—and sometimes a chance to feel your strength — that only — what you all regret?"

And we all nodded at him: the man of finance, the man of accounts, the man of law, we all nodded at him over the polished table that like a still sheet of brown water reflected our faces, lined, wrinkled; our faces marked by toil, by deceptions, by success, by love; our weary eyes looking still, looking always, looking anxiously for something out of life, that while it is expected is already gone—has passed unseen, in a sight, in a flash — together with the youth, with the strength, with the romance of illusions.

JOSEPH CONRAD

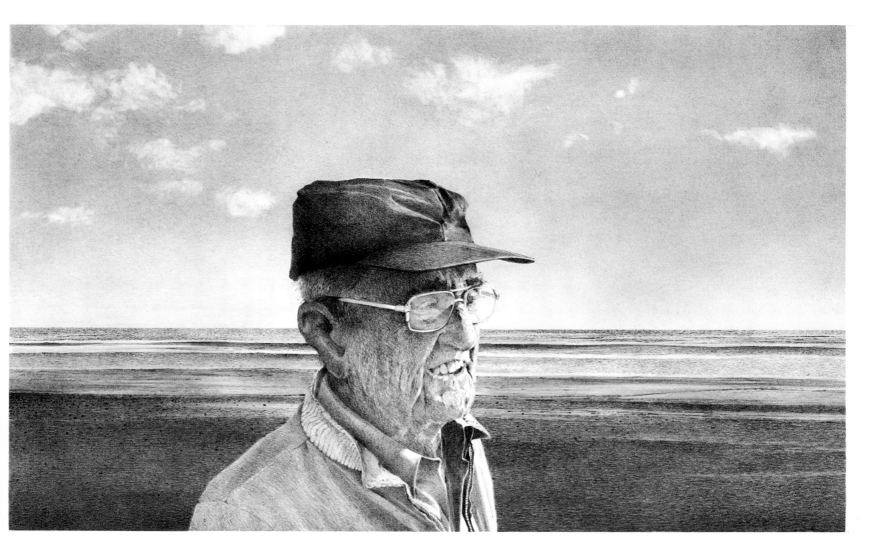

MAN FROM NEW BEDFORD

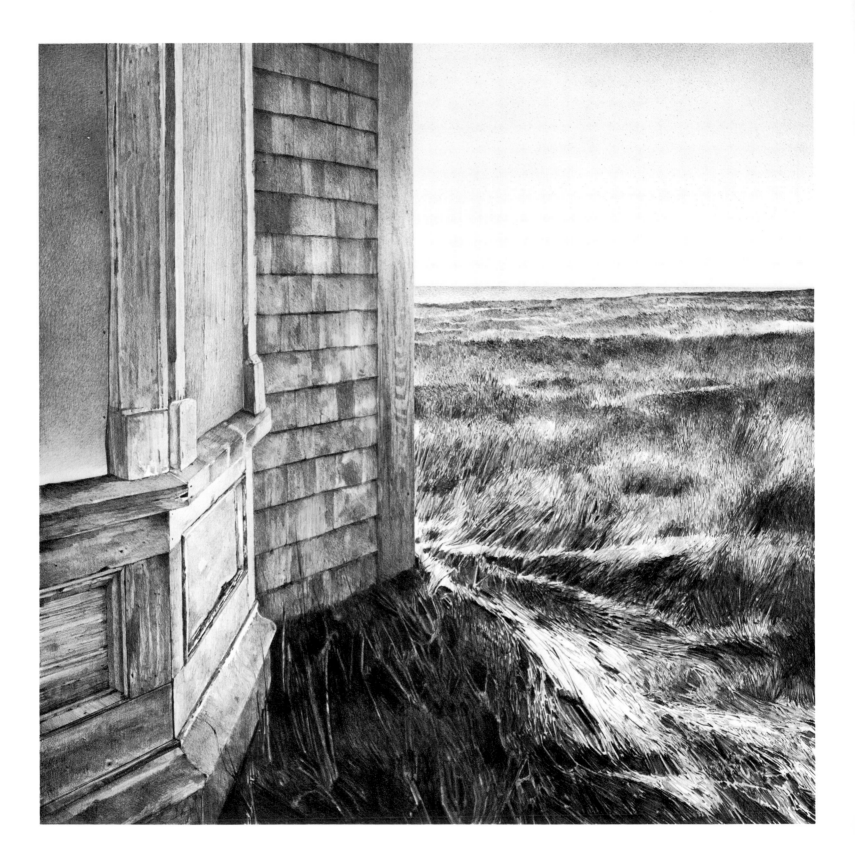

BEYOND THE HORIZON

The hushed twilight of a day in May is just beginning. The horizon hills are still rimmed by a faint line of flame, and the sky above them glows with the crimson flush of the sunset.

Robert Mayo is a tall slender young man of twenty-three. There is a touch of the poet about him expressed in his high forehead and wide, dark eyes . . . His brother Andrew is twenty-seven years old, an opposite type to Robert—husky, sun bronzed, handsome in a large-featured, manly fashion . . .

ANDREW. You should have gone back to college last fall, like I know you wanted to. You're fitted for that sort of thing—just as I ain't.

ROBERT. You know why I didn't go back, Andy. Pa didn't like the idea, even if he didn't say so; and I know he wanted the money to use improving the farm. And besides, I'm not keen on being a student, just because you see me reading books all the time. What I want to do now is keep on moving so that I won't take root in any one place.

ANDREW. Well, the trip you're leaving on to-morrow will keep you moving all right. *(At this mention of the trip they both fall silent. There is a pause. Finally* ANDREW *goes on, awkwardly, attempting to speak casually.)* Uncle says you'll be gone three years.

ROBERT. About that, he figures.

ANDREW. *(Moodily.)* That's a long time.

ROBERT. Not so long when you come to consider it. You know the *Sunda* sails around the Horn for Yokohama first, and that's a long voyage on a sailing ship; and if we go to any of the other places Uncle Dick mentions — India, or Australia, or South Africa, or South America—they'll be long voyages, too.

ANDREW. You can have all those foreign parts for all of me. *(After a pause.)* Ma's going to miss you a lot, Rob.

ROBERT. Yes—and I'll miss her.

ANDREW. And, Pa ain't feeling none too happy to have you go—though he's been trying not to show it.

ROBERT. I can see how he feels.

ANDREW. And you can bet that I'm not giving any cheers about it. *(He puts one hand on the fence near* ROBERT.)

ROBERT. *(Putting one hand on top of* AN-DREW'S *with a gesture almost of shyness.)* I know that, too, Andy.

ANDREW. I'll miss you as much as anybody, I guess. You see, you and I ain't like most brothers — always fighting and separated a lot of the time, while we've always been together — just the two of us. It's different with us. That's why it hits so hard, I guess.

ROBERT. *(With feeling.)* It's just as hard for me, Andy—believe that! I hate to leave you and the old folks—but—I feel I've got to. There's something calling me—*(He points to the horizon.)* Oh, I can't just explain it to you, Andy.

ANDREW. No need to, Rob. *(Angry at himself.)* Hell! You want to go—that's all there is to it; and I wouldn't have you miss this chance for the world.

ROBERT. It's fine of you to feel that way, Andy.

ANDREW. Huh! I'd be a nice son-of-a-gun if I didn't, wouldn't I? When I know how you need this sea trip to make a new man of you — in the body, I mean—and give you your full health back.

ROBERT. *(A trifle impatiently.)* All of you seem to keep harping on my health. You were so used to seeing me lying around the house in the old days that you never will get over the notion that I'm a chronic invalid. You don't realize how I've bucked up in the past few years. If I had no other excuse for going on Uncle Dick's ship but just

my health, I'd stay right here and start in plowing.

ANDREW. Can't be done. Farming ain't your nature. There's all the difference shown in just the way us two feel about the farm. You — well, you like the home part of it, I expect; but as a place to work and grow things, you hate it. Ain't that right?

ROBERT. Yes, I suppose it is. For you it's different. You're a Mayo through and through. You're wedded to the soil. You're as much a product of it as an ear of corn is, or a tree. Father is the same. This farm is his life-work, and he's happy in knowing that another Mayo, inspired by the same love, will take up the work where he leaves off. I can understand your attitude, and Pa's; and I think it's wonderful and sincere. But I — well, I'm not made that way.

ANDREW. No, you ain't; but when it comes to understanding, I guess I realize that you've got your own angle of looking at things.

ROBERT. (Musingly.) I wonder if you do really.

ANDREW. (Confidently.) Sure I do. You've seen a bit of the world, enough to make the farm seem small, and you've got the itch to see it all.

ROBERT. It's more than that, Andy.

ANDREW. Oh, of course. I know you're going to learn navigation, and all about a ship, so's you can be an officer. That's natural, too. There's fair pay in it, I expect, when you consider that you've always got a home and grub thrown in; and if you're set on traveling, you can go anywhere you're a mind to without paying fare.

ROBERT. (With a smile that is half sad.) It's more than that, Andy.

ANDREW. Sure it is. There's always a chance of a good thing coming your way in some of those foreign ports or other. I've heard there are great opportunities for a young fellow with his eyes open in some of those new countries that are just being opened up. (Jovially.). I'll bet that's what you've been turning over in your mind under all your quietness! (He slaps his brother on the back, with a laugh.) Well, if you get to be a millionaire all of a sudden, call 'round once in a while and I'll pass the plate to you. We could use a lot of money right here on the farm without hurting it any.

ROBERT. (Forced to laugh.) I've never considered that practical side of it for a minute, Andy.

ANDREW. Well, you ought to.

ROBERT. No, I oughtn't. (Pointing to the horizon — dreamily.) Supposing I was to tell you that it's just Beauty that's calling me, the beauty of the far off and unknown, the mystery and spell of the East which lures me in the books I've read, the need of the freedom of great wide spaces, the joy of wandering on and on—in quest of the secret which is hidden over there, beyond the horizon? Suppose I told you that was the one and only reason for my going?

ANDREW. I should say you were nutty.

ROBERT. (Frowning.) Don't, Andy. I'm serious.

ANDREW. Then you might as well stay here, because we've got all you're looking for right on this farm. There's wide space enough, Lord knows; and you can have all the sea you want by walking a mile down to the beach; and there's plenty of horizon to look at, and beauty enough for anyone, except in the winter. (He grins.) As for the mystery and spell, I haven't met 'em yet, but they're probably lying around somewheres. I'll have you understand this is a first class farm with all the fixings. (He laughs.)

ROBERT. (Joining in the laughter in spite of himself.) It's no use talking to you, you chump!

EUGENE O'NEILL

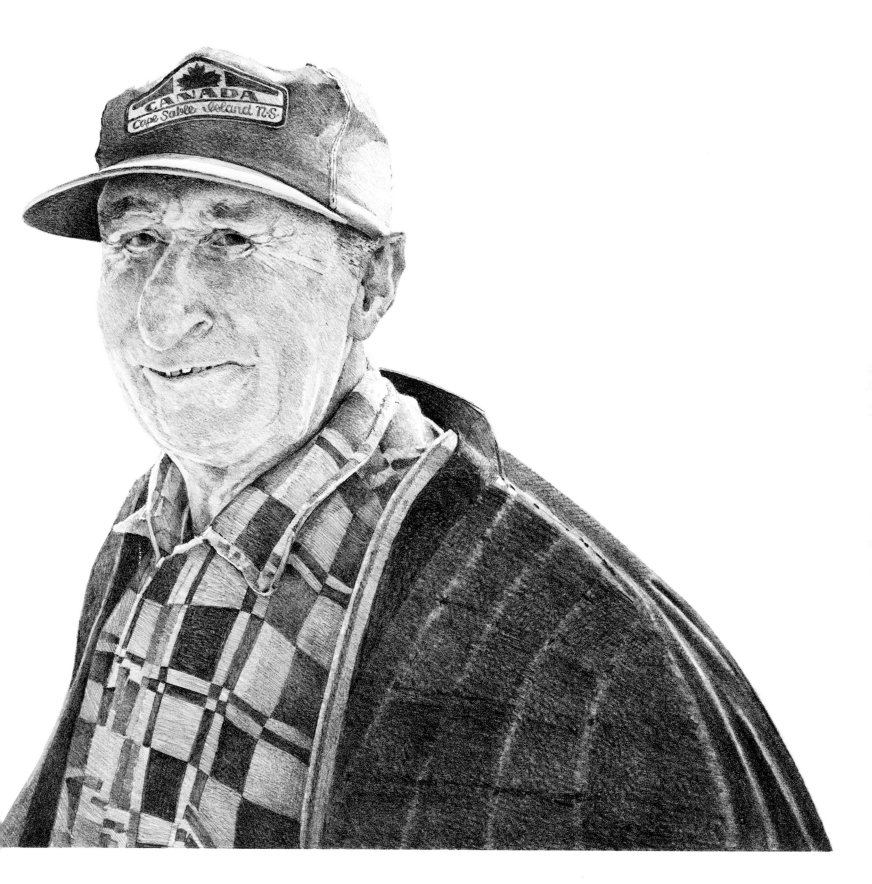

"A man who'd go to sea for fun'd go to hell for a pastime"
MALCOLM LOWRY

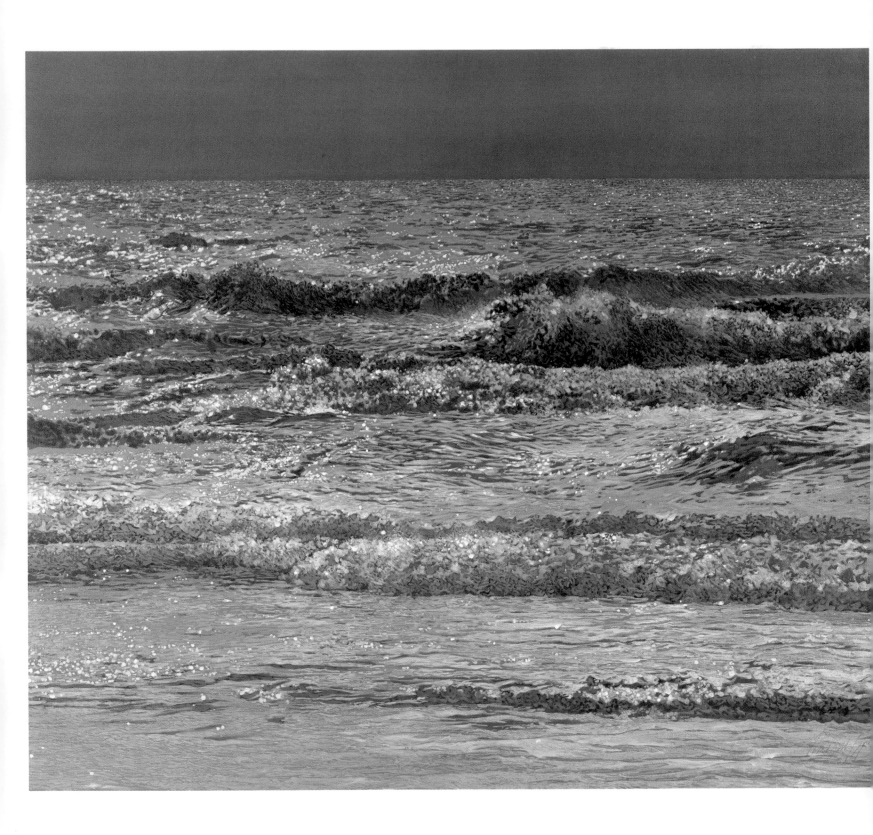

For all that has been said of the love that certain natures (on shore) have professed to feel for it, for all the celebrations it has been the object of in prose and song, the sea has never been friendly to man. At most it has been the accomplice of human restlessness.

JOSEPH CONRAD

CALL ME ISHMAEL. Some years ago—never mind how long precisely—having little or no money in my purse, and nothing particular to interest me on shore, I thought I would sail about a little and see the watery part of the world. It is a way I have of driving off the spleen, and regulating the circulation. Whenever I find myself growing grim about the mouth; whenever it is a damp, drizzly November in my soul; whenever I find myself involuntarily pausing before coffin warehouses, and bringing up the rear of every funeral I meet; and especially whenever my hypos get such an upper hand of me, that it requires a strong moral principle to prevent me from deliberately stepping into the street, and methodically knocking people's hats off—then, I account it high time to get to sea as soon as I can. This is my substitute for pistol and ball. With a philosophical flourish Cato throws himself upon his sword; I quietly take to the ship. There is nothing surprising in this. If they but knew it, almost all men in their degree, some time or other, cherish very nearly the same feelings towards the ocean with me.

HERMAN MELVILLE

EARLY IMPRESSIONS

We steamed out of the Clyde on Thursday night, and early on the Friday forenoon we took in our last batch of emigrants at Lough Foyle, in Ireland, and said farewell to Europe. The company was now complete, and began to draw together, by inscrutable magnetisms, upon the deck. There were Scots and Irish in plenty, a few English, a few Americans, a good handful of Scandinavians, a German or two, and one Russian; all now belonging for ten days to one small iron country on the deep.

As I walked the deck and looked round upon my fellow-passengers, thus curiously assorted from all northern Europe, I began for the first time to understand the nature of emigration. Day by day throughout the passage, and thenceforward across all the States, and on to the shores of the Pacific, this knowledge grew more clear and melancholy. Emigration, from a word of the most cheerful import, came to sound most dismally in my ear. There is nothing more agreeable to picture and nothing more pathetic to behold. The abstract idea, as conceived at home, is hopeful and adventurous. A young man, you fancy, scorning restraints and helpers, issues forth into life, that great battle, to fight for his own hand. The most pleasant stories of ambition, of difficulties overcome, and of ultimate success, are but as episodes to this great epic of self-help. The epic is composed of individual heroisms; it stands to them as the victorious war which subdued an empire stands to the personal act of bravery which spiked a single cannon and was adequately rewarded with a medal. For in emigration the young men enter direct and by the shipload on their heritage or work; empty continents swarm, as at the bo'sun's whistle, with industrious hands, and whole new empires are domesticated to the service of man.

This is the closet picture, and is found, on trial, to consist mostly of embellishments. The more I saw of my fellow-passengers, the less I was tempted to the lyric note. Comparatively few of the men were below thirty; many were married and encumbered with families; not a few were already up in years; and this itself was out of tune with my imaginations, for the ideal emigrant should certainly be young. Again, I thought he should offer to the eye some bold type of humanity, with bluff or hawk-like features, and the stamp of an eager and pushing disposition. Now those around me were for the most part quiet, orderly, obedient citizens, family men broken by adversity, elderly youths who had failed to place themselves in life, and people who had seen better days. Mildness was the prevailing character; mild mirth and mild endurance. In a word I was not taking part in an impetuous and conquering sally, such as swept over Mexico or Siberia, but found myself, like Marmion, "in the lost battle, borne down by the flying."

Labouring mankind had in the last years, and throughout Great Britain, sustained a prolonged and crushing series of defeats. I had heard vaguely of these reverses; of whole streets of houses standing deserted by the Tyne, the cellar-doors broken and removed for firewood; of homeless men loitering at the street-corners of Glasgow with their chests beside them; of closed factories, useless strikes, and starving

girls. But I had never taken them home to me or represented these distresses livingly to my imagination. A turn of the market may be a calamity as disastrous as the French retreat from Moscow; but it hardly lends itself to lively treatment, and makes a trifling figure in the morning papers. We may struggle as we please, we are not born economists. The individual is more affecting than the mass. It is by the scenic accidents, and the appeal to the carnal eye, that for the most part we grasp the significance of tragedies. Thus it was only now, when I found myself involved in the rout, that I began to appreciate how sharp had been the battle. We were a company of the rejected; the drunken, the incompetent, the weak, the prodigal, all who had been unable to prevail against circumstances in the one land, were not fleeing pitifully to another; and though one or two might still succeed, all had already failed. We were a shipful of failures, the broken men of England. Yet it must not be supposed that these people exhibited depression. The scene, on the contrary, was cheerful. Not a tear was shed on board the vessel. All were full of hope for the future, and showed an inclination to innocent gaiety. Some were heard to sing, and all began to scrape acquaintance with small jests and ready laughter.

The children found each other out like dogs, and ran about the decks scraping acquaintance after their fashion also. "What do you call your mither?" I heard one ask. "Mawmaw," was the reply, indicating, I fancy, a shade of difference in the social scale. When people pass each other on the high seas of life at so early an age, the contact is but slight, and the relation more like what we may imagine to be the friendship of flies than that of men; it is so quickly joined, so easily dissolved, so open in its communications and so devoid of deeper human qualities. The children, I observed, were all in a band, and as thick as thieves at a fair, while their elders were still ceremoniously manoeuvring on the outskirts of acquaintance. The sea, the ship, and the seamen were soon as familiar as home to these half-conscious little ones. It was odd to hear them, throughout the voyage, employ shore words to designate portions of the vessel. "Co' 'way doon to yon dyke," I heard one say, probably meaning the bulwark. I often had my heart in my mouth, watching them climb into the shrouds or on the rails while the ship went swinging through the waves; and I admired and envied the courage of their mothers, who sat by in the sun and looked on with composure at these perilous feats. "He'll maybe be a sailor," I heard one remark; "now's the time to learn." I had been on the point of running forward to interfere, but stood back at that, reproved. Very few in the more delicate classes have the nerve to look upon the peril of one dear to them; but the life of poorer folk, where necessity is so much more immediate and imperious, braces even a mother to this extreme of endurance. And perhaps, after all, it is better that the lad should break his neck than that you should break his spirit.

And since I am here on the chapter of the children, I must mention one little fellow, whose family belonged to Steerage No. 4 and 5, and who, wherever he went, was like a strain of music round the ship. He was an ugly, merry, unbreeched child of three, his lint-white hair in a tangle, his face smeared with suet and treacle; but he ran to and fro with so natural a step, and fell and picked himself up again with such grace and

good-humour, that he might fairly be called beautiful when he was in motion. To meet him, crowing with laughter and beating an accompaniment to his own mirth with a tin spoon upon a tin cup, was to meet a little triumph of the human species. Even when his mother and the rest of his family lay sick and prostrate around him, he sat upright in their midst and sang aloud in the pleasant heartlessness of infancy.

Throughout the Friday, intimacy among us men made but few advances. We discussed the probable duration of the voyage, we exchanged pieces of information, naming our trades, what we hoped to find in the new world, or what we were fleeing from in the old; and, above all, we condoled together over the food and the vileness of the steerage. One or two had been so near famine that you may say they had run into the ship with the devil at their heels; and to these all seemed for the best in the best of possible steamers. But the majority were hugely discontented. Coming as they did from a country in so low a state as Great Britain, many of them from Glasgow, which commercially speaking was as good as dead, and many having long been out of work, I was surprised to find them so dainty in their notions. I myself lived almost exclusively on bread, porridge, and soup, precisely as it was supplied to them, and found it, if not luxurious, at least sufficient. But these working men were loud in the outcries. It was not "food for human beings," it was "only fit for pigs," it was "a disgrace." Many of them lived almost entirely upon biscuit, others on their own private supplies, and some paid extra for better rations from the ship. This marvellously changed my notion of the degree of luxury habitual to the artisan. I was prepared to hear him grumble, for grumbling is the traveller's pastime; but I was not prepared to find him turn away from a diet which was palatable to myself. Words I should have disregarded, or taken with a liberal allowance; but when a man prefers dry biscuit there can be no question of the sincerity of his disgust.

With one of their complaints I could most heartily sympathise. A single night of the steerage had filled them with horror. I had myself suffered, even in my decent second-cabin berth, from the lack of air; and as the night promised to be fine and quiet, I determined to sleep on deck, and advised all who complained of their quarters to follow my example. I daresay a dozen of others agreed to do so, and I thought we should have been quite a party. Yet when I brought up my rug about seven bells, there was no one to be seen but the watch. That chimerical terror of good night-air, which makes men close their windows, list their doors, and seal themselves up with their own poisonous exhalations, had sent all these healthy workmen down below. One would think we had been brought up in a fever country; yet in England the most malarious districts are in the bedchambers.

I felt saddened at this defection, and yet half-pleased to have the night so quietly to myself. The wind had hauled a little ahead on the starboard bow, and was dry but chilly. I found a shelter near the fire-hole, and made myself snug for the night. The ship moved over the uneven sea with a gentle and cradling movement. The ponderous, organic labours of the engine in her bowels occupied the mind, and prepared it for slumber. From time to time a heavier lurch would disturb me as I lay, and recall me to the obscure borders of

consciousness; or I heard, as it were through a veil, the clear note of the clapper on the brass and the beautiful sea-cry, "All's well!" I know nothing, whether for poetry or music, that can surpass the effects of these two syllables in the darkness of a night at sea.

The day dawned fairly enough, and during the early part we had some pleasant hours to improve acquaintance in the open air; but towards nightfall the wind freshened, the rain began to fall, and the sea rose so high that it was difficult to keep one's footing on the deck (I have spoken of our concerts.) We were indeed a musical ship's company, and cheered our way into exile with the fiddle, the accordion, and the songs of all nations. (Night after night we gathered at the aftermost limit of our domain, where it bordered on that of the saloon. Performers were called up with acclamation, some shame-faced and hanging the head, others willing and as bold as brass.) Good, bad, or indifferent — Scottish, English, Irish, Russian, German or Norse, — the songs were received with generous applause. Once or twice, a recitation, very spiritedly rendered in a powerful Scottish accent, varied the proceed-ings; and once we sought in vain to dance a quadrille, eight men of us together, to the music of the violin. The performers were all humorous, frisky fellows, who loved to cut capers in private life; but as soon as they were arranged for the dance, they conducted themselves like so many mutes at a funeral. I have never seen decorum pushed so far; and as this was not expected, the quadrille was soon whistled down, and the dancers departed under a cloud. Eight Frenchmen, even eight Englishmen from another rank of society, would have dared to make some fun for themselves and the spectators; but the working man, when sober, takes an extreme and even melancholy view of personal deportment. A fifth-form schoolboy is not more careful of dignity. He dares not be comical; his fun must escape from him unprepared, and above all, it must be unaccompanied by any physical de-monstration. I like his society under most circumstances, but let me never again join with him in public gambols.

But the impulse to sing was strong, and triumphed over modesty and even the inclemencies of sea and sky. On this rough Saturday night, we got together by the main deck-house, in a place sheltered from the wind and rain. Some clinging to a ladder which led to the hurricane deck, and the rest knitting arms or taking hands, we made a ring to support the women in the violent lurching of the ship; and when we were thus disposed, sang to our hearts' content. Some of the songs were appropriate to the scene; others strikingly the reverse. Bastard doggerel of the music-hall, such as, "Around her splendid form, I weaved the magic circle," sounded bald, bleak, and pitifully silly. "We don't want to fight, but, by Jingo, if we do," was in some measure saved by the vigour and unanimity with which the chorus was thrown forth into the night. I observed a Platt-Deutsch mason, entirely innocent of English, adding heartily to the general effect. And perhaps the German mason is but a fair example of the sincerity with which the song was rendered; for nearly all with whom I conversed upon the subject were bitterly opposed to war, and attributed their own misfortunes, and frequently their own taste for whisky, to the campaigns in Zululand and Afghanistan.

Every now and again, however, some song that touched the pathos of our situation was given forth; and you could hear by the voices that took up the burden how the sentiment came home to each. "The Anchor's Weighed" was true for us. We were indeed "Rocked on the bosom of the stormy deep." How many of us could say with the singer, "I'm lonely to-night, love, without you," or "Go, some one, and tell them from me, to write me a letter from home!" And when was there a more appropriate moment for "Auld Lang Syne" than now, when the land, the friends, and the affections of that mingled but beloved time were fading and fleeing behind us in the vessel's wake? It pointed forward to the hour when these labours should be overpast, to the return voyage, and to many a meeting in the sanded inn,[1] when those who had parted in the spring of youth should again drink a cup of kindness in their age. Had not Burns contemplated emigration, I scarce believe he would have found that note.

This was the first fusion of our little nationality together. The wind sang shrill in the rigging; the rain fell small and thick; the whole group, linked together as it was, was shaken and swung to and fro as the swift steamer shore into the waves. It was a general embrace, both friendly and helpful, like what one imagines of old Christian Agapes. I turned many times to look behind me on the moving desert of seas, now cloud-canopied and lit with but a low nocturnal glimmer along the line of the horizon. It hemmed us in and cut us off on our swift-travelling oasis. And yet this waste was part a playground for the stormy petrel; and on the least tooth of reef, outcropping in a thousand miles of unfathomable ocean, the gull makes its home and dwells in a busy polity. And small as was our iron world, it made yet a large and habitable place in the Atlantic, compared with our globe upon the seas of space.

All Sunday the weather remained wild and cloudy; many were prostrated by sickness; only five sat down to tea in the second cabin, and two of these departed abruptly ere the meal was at an end. The Sabbath was observed strickly by the majority of the emigrants. I heard an old woman express her surprise that "the ship didna gae doon," as she saw some one pass her with a chess-board on the holy day. Some sang Scottish psalms. Many went to service, and in true Scottish fashion came back ill pleased with their divine. "I didna think he was an experienced preacher,' said one girl to me.

It was a bleak, uncomfortable day; but at night, by six bells, although the wind had not yet moderated, the clouds were all wrecked and blown away behind the rim of the horizon, and the stars came out thickly overhead. I saw Venus burning as steadily and sweetly across this hurly-burly of the winds and waters as ever at home upon the summer woods. The engine pounded, the screw tossed out of the water with a roar, and shook the ship from end to end; the bows battled with loud reports against the billows; and as I stood in the lee-scuppers and looked up to where the funnel leaned out over my head, vomiting smoke, and the black and monstrous topsails blotted, at each lurch, a different crop of stars, it seemed as if all this trouble were a thing of small account, and that just above the mast reigned peace unbroken and eternal.

ROBERT LOUIS STEVENSON

1. Country inns often had their floors strewn with sand for cleanliness and ornament.

SAILING ALONE AROUND THE WORLD

No one can know the pleasure of sailing free over the great oceans save those who have had the experience. It is not necessary, in order to realize the utmost enjoyment of going around the globe, to sail alone, yet for once and the first time there was a great deal of fun in it. My friend the government expert, and saltest of salt sea-captains, standing only yesterday on the deck of the *Spray*, was convinced of her famous qualities, and he spoke enthusiastically of selling his farm on Cape Code and putting to sea again.

To young men contemplating a voyage I would say go. The tales of rough usage are for the most part exaggerations, as also are the stories of sea danger. I had a fair schooling in the so-called "hard ships" on the hard Western Ocean, and in the years there I do not remember having once been "called out of my name." Such recollections have endeared the sea to me. I owe it further to the officers of all ships I ever sailed in as boy and man to say that not one ever lifted so much as a finger to me. I did not live among angels, but among men who could be roused. My wish was, though, to please the officers of my ship wherever I was, and so I got on. Dangers there are, to be sure, on the sea as well as on the land, but the intelligence and skill God gives to man reduce these to a minimum. And here comes in again the skilfully modeled ship worthy to sail the seas.

To face the elements is, to be sure, no light matter when the sea is in its grandest mood. You must then know the sea, and know that you know it, and not forget that it was made to be sailed over.

JOSHUA SLOCUM

I had now completely got over my seasickness, and felt very well, at least in my body, though my heart was far from feeling right, so that I could now look around me and make observations.

And truly, though we were at sea, there was much to behold and wonder at, to me, who was on my first voyage. What most amazed me was the sight of the great ocean itself, for we were out of sight of land. All round us, on both sides of the ship, ahead and astern, nothing was to be seen but water —water—water; not a single glimpse of green shore, not the smallest island, or speck of moss anywhere. Never did I realize till now what the ocean was: how grand and majestic, how solitary, and boundless, and beautiful and blue; for that day it gave no tokens of squalls or hurricanes, such as I had heard my father tell of; nor could I imagine how anything that seemed so playful and placid could be lashed into rage, and troubled into rolling avalanches of foam, and great cascades of waves, such as I saw in the end.

As I looked at it so mild and sunny, I could not help calling to my mind my little brother's face, when he was sleeping an infant in the cradle. It had just such a happy, careless, innocent look; and every happy little wave seemed gambolling about like a thoughtless little kid in a pasture, and seemed to look up in your face as it passed, as if it wanted to be patted and caressed. They seemed all live things with hearts in them, that could feel; and I almost felt grieved as we sailed in among them, scattering them under our broad bows in sunflakes, and riding over them like a great elephant among lambs.

But what seemed perhaps the most strange to me of all was a certain wonderful rising and falling of the sea; I do not mean the waves themselves, but a sort of wide heaving and swelling and sinking all over the ocean. It was something I cannot very well describe; but I know very well what it was, and how it affected me. It made me almost dizzy to look at it, and yet I could not keep my eyes off it, it seemed so passing strange and wonderful.

I felt as if in a dream all the time; and when I could shut the ship out, almost thought I was in some new, fairy world, and expected to hear myself called to, out of the clear blue air, or from the depths of the deep blue sea. But I did not have much leisure to indulge in such thoughts, for the men were now getting some *stun'-sails* ready to hoist aloft, as the wind was getting fairer and fairer for us; and these stun'-sails are light canvas which are spread at such times, away out beyond the ends of the yards, where they overhang the wide water like the wings of a great bird.

HERMAN MELVILLE

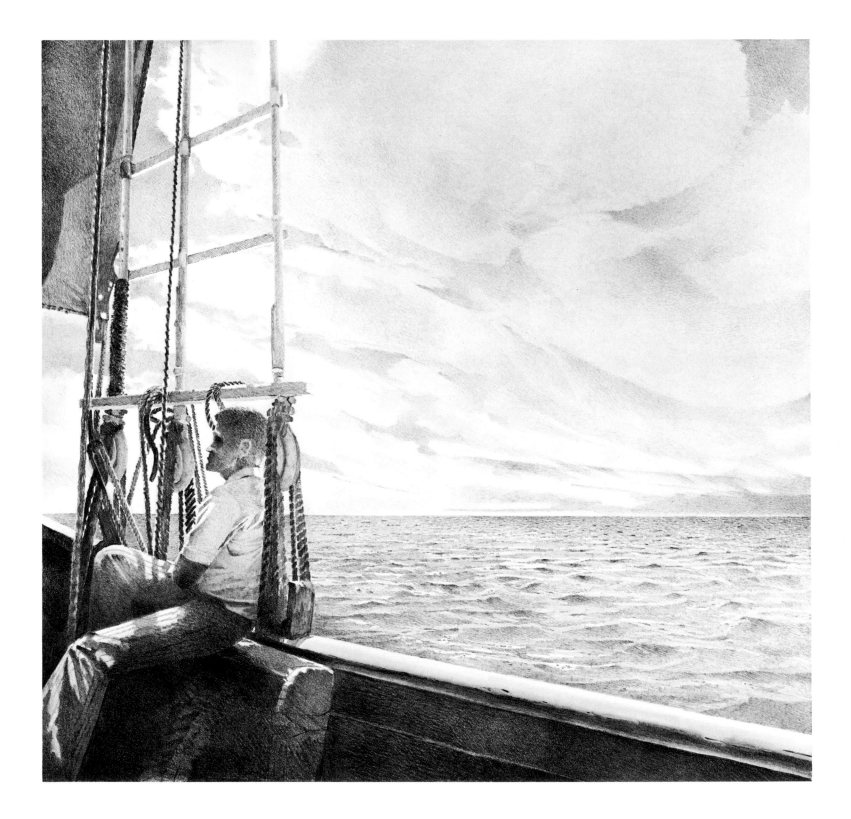

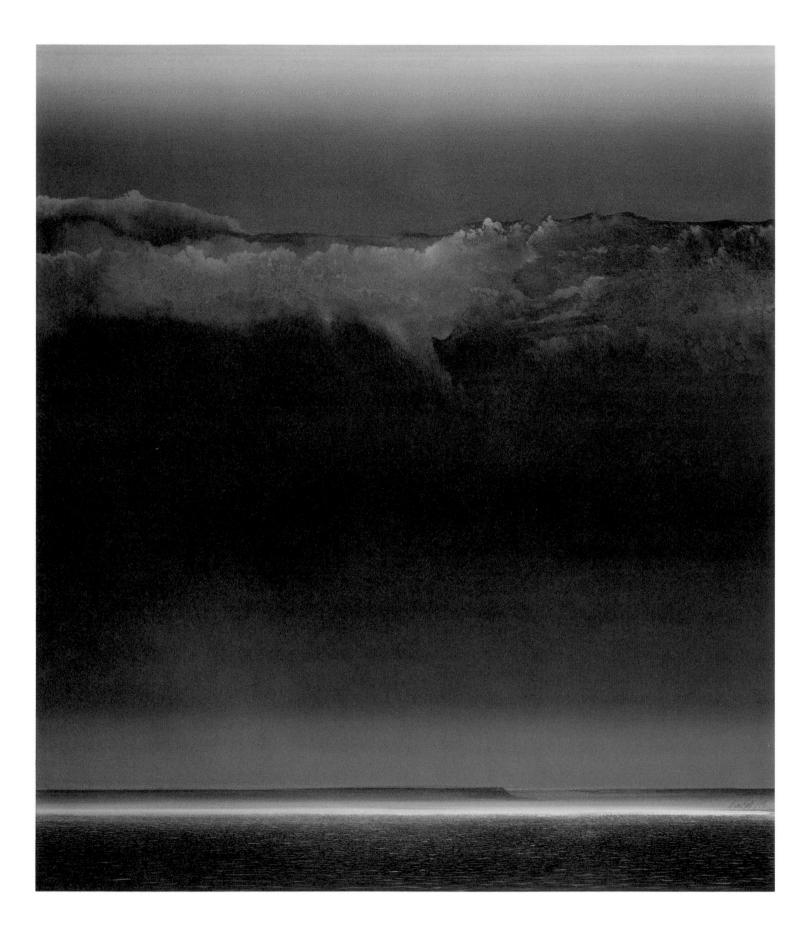

By eleven o'clock the sea had become glass. By mid-day, though we were well up in the northerly latitudes, the heat was sickening. There was no freshness in the air. It was sultry and oppressive, reminding me of what the old Californians term "earthquake weather." There was something ominous about it, and in intangible ways one was made to feel that the worst was about to come. Slowly the whole eastern sky filled with clouds that overtowered us like some black sierra of the infernal regions. So clearly could one see cañon, gorge, and precipice, and the shadows that lie therein, that one looked unconsciously for the white surf-line and bellowing caverns where the sea charges on the land. And still we rocked gently, and there was no wind.

JACK LONDON

It was something formidable and swift, like the sudden smashing of a vial of wrath. It seemed to explode all round the ship with an overpowering concussion and a rush of great waters, as if an immense dam had been blown up to windward. In an instant the men lost touch of each other. This is the disintegrating power of a great wind: it isolates one from one's kind. An earthquake, a landslip, an avalanche, overtake a man incidentally, as it were—without passion. A furious gale attacks him like a personal enemy, tries to grasp his limbs, fastens upon his mind, seeks to rout his very spirit out of him.

Jukes was driven away from his commander. He fancied himself whirled a great distance through the air. Everything disappeared—even, for a moment, his power of thinking; but his hand had found one of the rail-stanchions. His distress was by no means alleviated by an inclination to disbelieve the reality of this experience. Though young, he had seen some bad weather, and had never doubted his ability to imagine the worst; but this was so much beyond his powers of fancy that it appeared incompatible with the existence of any ship whatever. He would have been incredulous about himself in the same way, perhaps, had he not been so harassed by the necessity of exerting a wrestling effort against a force trying to tear him away from his hold. Moreover, the conviction of not being utterly destroyed returned to him through the sensations of being half-drowned, bestially shaken, and partly choked.

It seemed to him he remained there precariously alone with the stanchion for a long, long time. The rain poured on him, flowed, drove in sheets. He breathed in gasps; and sometimes the water he swallowed was fresh and sometimes it was salt. For the most part he kept his eyes shut tight, as if suspecting his sight might be destroyed in the immense flurry of the elements. When he ventured to blink hastily, he derived some moral support from the green gleam of the starboard light shining feebly upon the flight of rain and sprays. He was actually looking at it when its ray fell upon the uprearing sea which put it out. He saw the head of the wave topple over, adding the mite of its crash to the tremendous uproar raging around him, and almost at the same instant the stanchion was wrenched away from his embracing arms. After a crushing thump on his back he found himself suddenly afloat and borne upwards. His first irresistible notion was that the whole China Sea had climbed on the bridge. Then, more sanely, he concluded himself gone overboard. All the time he was being tossed, flung, and rolled in great volumes of water, he kept on repeating mentally with the utmost precipitation, the words: "My God! My God! My God! My God!"

JOSEPH CONRAD

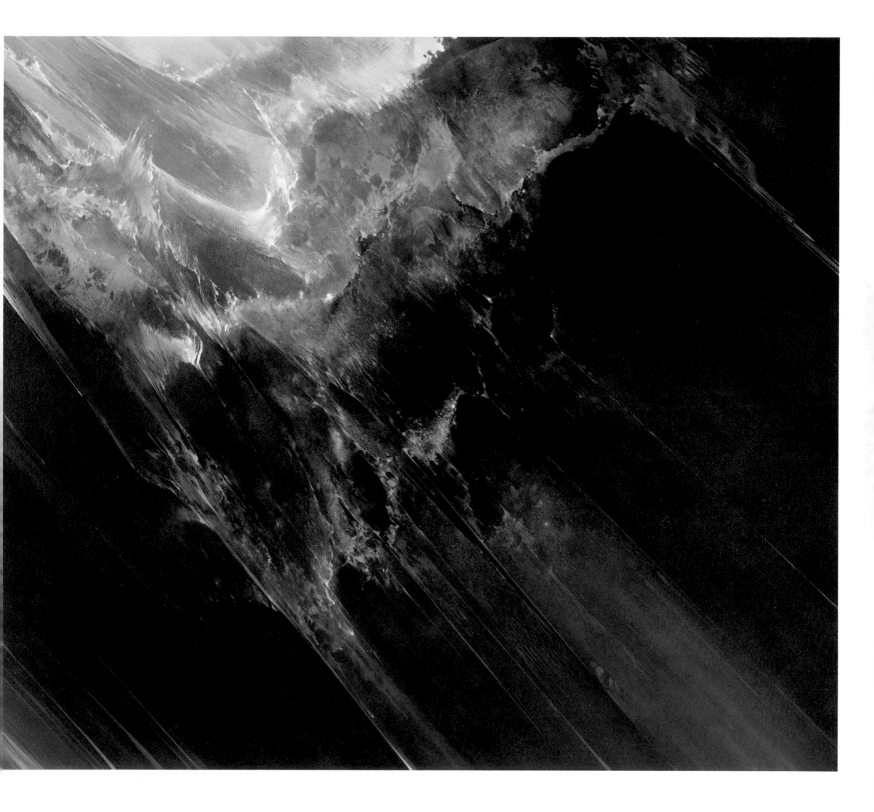

THE CRUEL SEA

There was a muffled explosion, which they could each feel like a giant hand squeezing their stomachs, and *Compass Rose* began to slide down. Now she went quickly, as if glad to be quit of her misery: the mast snapped in a ruin of rigging as she fell. When the stern dipped beneath the surface, a tumult of water leapt upwards: then the smell of oil came thick and strong towards them. It was a smell they had got used to, on many convoys: they had never thought that *Compass Rose* would ever exude the same disgusting stench.

The sea flattened, the oil spread, their ship was plainly gone: a matter of minutes had wiped out a matter of years. Now the biting cold, forgotten before the huge disaster of their loss, began to return. They were bereaved and left alone in the darkness; fifty men, two rafts, misery, fear, and the sea.

On the rafts, in the whispering misery of the night that would not end, men were either voices or silences: if they were silences for too many minutes, it meant that they need no longer be counted in, and their places might be taken by others who still had a margin of life and warmth in their bodies.

'Christ, it's cold. . . .'

'How far away was the convoy?'

'About thirty miles.'

'Shorty . . .'

'Did anyone see Jameson?'

'He was in the fo'c'sle.'

'None of *them* got out.'

'Lucky bastards. . . . Better than this, any road.'

'We've got a chance still.'

'It's getting lighter.'

'That's the moon.'

'Shorty . . . Wake up. . . .'

'She must've gone down inside of five minutes.'

'Like *Sorrel*.'

'Thirty miles off, they should have got us on the radar.'

'If they were watching out properly.'

'Who was stern escort?'

'*Trefoil*.'

'Shorty . . .'

'How many on the other raft?'

'Same as us, I reckon.'

'Christ, it's cold.'

'Wind's getting up, too.'

'I'd like to meet the bastard that put us here.'

'Once is enough for me.'

'Shorty . . . What's the matter with you?'

'Must be pretty near Iceland.'

'We don't need telling that.'

'*Trefoil*'s all right. They ought to have seen us on the radar.'

'Not with some half-asleep sod of an operator on watch.'

'Shorty . . .'

'Stop saying that . . . ! Can't you see he's finished?'

'But he was talking to me.'

'That was an hour ago, you dope.'

'Wilson's dead, sir.'

'Sure?'

'Yes. Stone cold.'

'Tip him over, then. . . . Who's coming up next?'

'Any more for the Skylark?'

'What's the use? It's no warmer up on the raft.'

'Christ, it's cold. . . .'

At one point during the night, the thin crescent moon came through the ragged clouds, and illuminated for a few moments the desperate scene below. It shone on a waste of water, growing choppy with the biting wind: it shone on the silhouettes of men hunched together on the rafts, and the shadows of men clinging to them, and the blurred outlines of men in the outer ring, where the corpses wallowed and heaved, and the red lights burned and burned aimlessly on the breasts of those who, hours before, had switched them on in hope and confidence. For a few minutes the moon put this cold sheen upon the face of the water, and upon the foreheads of the men whose heads were still upright; and then it withdrew, veiling itself abruptly as if, in pity and amazement, it had seen enough, and knew that men in this extremity deserved only the decent mercy of darkness.

Ferraby did not die: but towards dawn it seemed to him that he *did* die, as he held Rose, the young signalman, in his arms, and Rose died for him. Throughout the night Rose had been sitting next to him on the raft, and sometimes they had talked and sometimes fallen silent: it had recalled that other night of long ago, their first night at sea, when he and Rose had chatted to each other and, urged on by the darkness and loneliness of their new surroundings, had drawn close together. Now the need for closeness was more compelling still, and they had turned to each other again, in an unspoken hunger for comfort, so young and unashamed that presently they found that they were holding hands. . . . But in the end Rose had fallen silent, and had not answered his questions, and had sagged against him as if he had gone to sleep: Ferraby had put his arm around him and, when he slipped down farther still, had held him on his knees.

After waiting, afraid to put it to the test, he said: 'Are you all right, Rose?' There was no answer. He bent down and touched the face that was close under his own. By some instinct of compassion, it was with his lips that he touched it, and his lips came away icy and trembling. Now he was alone. ...The tears ran down Ferraby's cheeks, and fell on the open upturned eyes. In mourning and in mortal fear, he sat on, with the cold stiffening body of his friend like a dead child under his heart.

Lockhart did not die, though many times during the night there seemed to him little reason why this should be so. He had spent most of the dark hours in the water alongside Number Two Carley, of which he was in charge: only towards morning when there was room and to spare, did he climb on to it. From this slightly higher vantage point he looked around him, and felt the cold and smelt the oil, and saw the other raft nearby, and the troubled water in between; and he pondered the dark shadows which were dead men, and the clouds racing across the sky, and the single star overhead, and the sound of the bitter wind; and then with all this to daunt him and drain him of hope, he took a last grip on himself, and on the handful of men on the raft, and set himself to stay alive till daylight, and to take them along with him.

He made them sing, he made them move their arms and legs, he made them talk, he made them keep awake. He slapped their faces, he kicked them, he rocked the raft till they were forced to rouse themselves and cling on: he dug deep into his repertoire of filthy stories and produced a selection so pointless and so disgusting that he would have blushed to tell them, if the extra blood had been available. He made them act 'Underneath the Spreading Chestnut Tree', and play guessing games: he roused Ferraby from his dejected silence, and made him repeat all the poetry he knew: he imitated all the characters of ITMA, and forced the others to join in. He set them to paddling the raft round in circles, and singing the 'Volga Boatmen': recalling a childhood game, he divided them into three parties, and detailed them to shout 'Russia', 'Prussia', and 'Austria', at the same moment – a manoeuvre designed to sound like a giant and appropriate sneeze.... The men on his raft loathed him, and the sound of his voice, and his appalling optimism: they cursed him openly, and he answered them back in the same language, and promised them a liberal dose of detention as soon as they got back to harbour.

For all this, he drew on an unknown reserve of strength and energy which now came to his rescue. When he climbed out of the water, he felt miserably stiff and cold: the wild and foolish

activity, the clownish antics, soon restored him, and some of it communicated itself to some of the men with him, and some of them caught the point of it and became foolish and clownish and energetic in their turn, and so some of them saved their lives.

Sellars, Crowther, Gracey, and Tewson did not die. They were on Number Two Carley with Lockhart and Ferraby, and they were all that were left alive by morning, despite these frenzied efforts to keep at bay the lure and the sweetness of sleep. It was Tewson's first ship, and his first voyage: he was a cheerful young Cockney, and now and again during the night he had made them laugh by asking cheekily: 'Does this sort of thing happen *every* trip?' It was a pretty small joke, but (as Lockhart realized) it was the sort of contribution they had to have. ... There were other contributions: Sellars sang an interminable version of 'The Harlot of Jerusalem', Crowther (the sick-berth attendant who had been a vet) imitated animal noises, Gracey gave an exhibition of shadow-boxing which nearly overturned the raft. They did, in fact, the best they could; and their best was just good enough to save their lives.

The Captain did not die: it was as if, after *Compass Rose* went down, he had nothing left to die with. The night's 'examination' effort had been necessary, and so he had made it, automatically – but only as the Captain, in charge of a raftful of men who had always been owed his utmost care and skill: the effort had had no part of his heart in it. That heart seemed to have shrivelled, in the few terrible minutes between the striking of his ship, and her sinking: he had loved *Compass Rose*, not sentimentally, but with the pride and the strong attachment which the past three years had inevitably brought, and to see her thus contemptuously destroyed before his eyes had been an appalling shock. There was no word and no reaction appropriate to this wicked night: it drained him of all feeling. But still he had not died, because he was forty-seven, and a sailor, and tough and strong, and he understood – though now he hated – the sea.

All his men had longed for daylight: Ericson merely noted that it was now at hand, and that the poor remnants of his crew might yet survive. When the first grey light from the eastward began to creep across the water, he roused himself, and his men, and set them to paddling towards the other raft, which had drifted a full mile away. The light, gaining in strength, seeped round them as if borne by the bitter wind itself, and fell without pity upon the terrible pale sea, and the great streaks of oil, and the floating bundles that had been

living men. As the two rafts drew together, the figures on them waved to each other, jerkily, like people who could scarcely believe that they were not alone: when they were within earshot, there was a croaking hail from a man on Lockhart's raft, and Phillips, on the Captain's, made a vague noise in his throat in reply.

No one said anything more until the rafts met, and touched; and then they all looked at each other, in horror and in fear.

The two rafts were much alike. On each of them was the same handful of filthy oil-soaked men who still sat upright, while other men lay still in their arms or sprawled like dogs at their feet. Round them, in the water, were the same attendant figures — a horrifying fringe of bobbing corpses, with their meaningless faces blank to the sky and their hands frozen to the ratlines.

Between the dead and the living was no sharp dividing line. The men upright on the rafts seemed to blur with the dead men they nursed, and with the derelict men in the water, as part of the same vague and pitiful design.

Ericson counted the figures still alive on the other Carley. There were four of them, and Lockhart and Ferraby: they had the same fearful aspect as the men on his own raft: blackened, shivering, their cheeks and temples sunken with the cold, their limbs bloodless; men who, escaping death during the dark hours, still crouched stricken in its shadow when morning came. And the whole total was eleven. . . . He rubbed his hand across his frozen lips, and cleared his throat, and said:

'Well, Number One . . .'

'Well, sir . . .'

Lockhart stared back at Ericson for a moment, and then looked away. There could be nothing more, nothing to ease the unbearable moment.

The wind blew chill in their faces, the water slopped and broke in small ice-cold waves against the rafts, the harnessed fringe of dead men swayed like dancers. The sun was coming up now, to add dreadful detail: it showed the rafts, horrible in themselves, to be only single items in a whole waste of cruel water, on which countless bodies rolled and laboured amid countless bits of wreckage, adrift under the bleak sky. All round them, on the oily, fouled surface, the wretched flotsam, all that was left of *Compass Rose*, hurt and shamed the eye.

The picture of the year, thought Lockhart: 'Morning, with Corpses.'

NICHOLAS MONSARRAT

THE WAVES

The sun had not yet risen. The sea was indistinguishable from the sky, except that the sea was slightly creased as if a cloth had wrinkles in it. Gradually as the sky whitened a dark line lay on the horizon dividing the sea from the sky and the grey cloth became barred with thick strokes moving, one after another, beneath the surface, following each other, pursuing each other, perpetually.

As they neared the shore each bar rose, heaped itself, broke and swept a thin veil of white water across the sand. The wave paused, and then drew out again, sighing like a sleeper whose breath comes and goes unconsciously. Gradually the dark bar on the horizon became clear as if the sediment in an old wine-bottle had sunk and left the glass green. Behind it, too, the sky cleared as if the white sediment there had sunk, or as if the arm of a woman couched beneath the horizon had raised a lamp and flat bars of white, green and yellow spread across the sky like the blades of a fan. Then she raised her lamp higher and the air seemed to become fibrous and to tear away from the green surface flickering and flaming in red and yellow fibres like the smoky fire that roars from a bonfire. Gradually the fibres of the burning bonfire were fused into one haze, one incandescence which lifted the weight of the woollen grey sky on top of it and turned it to a million atoms of soft blue. The surface of the sea slowly became transparent and lay rippling and sparkling until the dark stripes were almost rubbed out. Slowly the arm that held the lamp raised it higher and then higher until a broad flame became visible; an arc of fire burnt on the rim of the horizon, and all round it the sea blazed gold.

VIRGINIA WOOLF

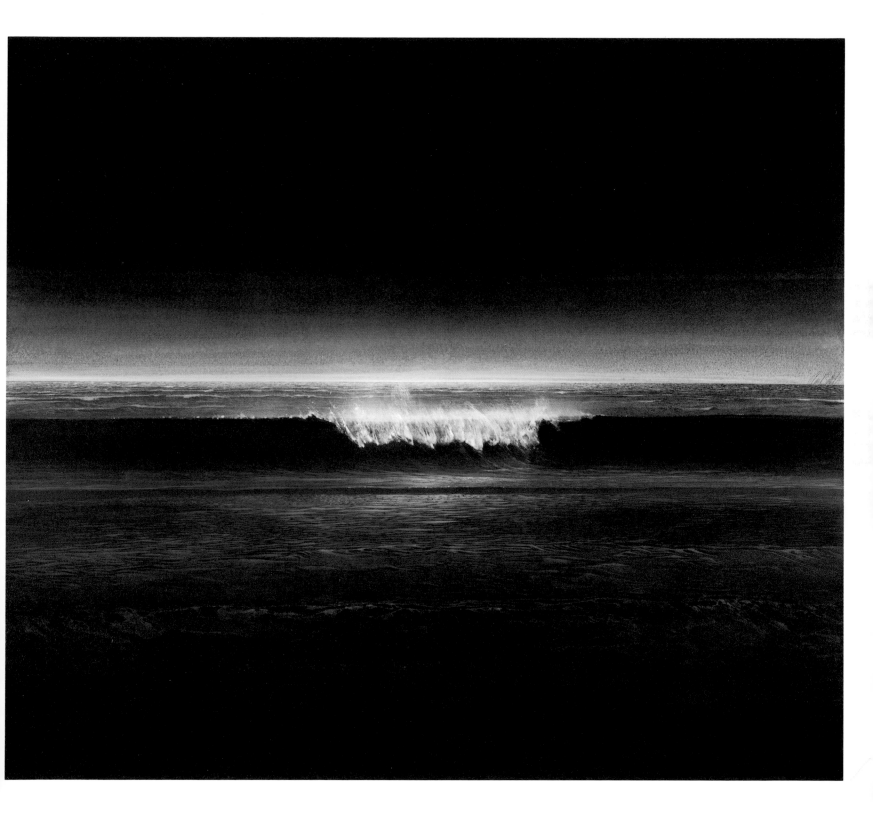

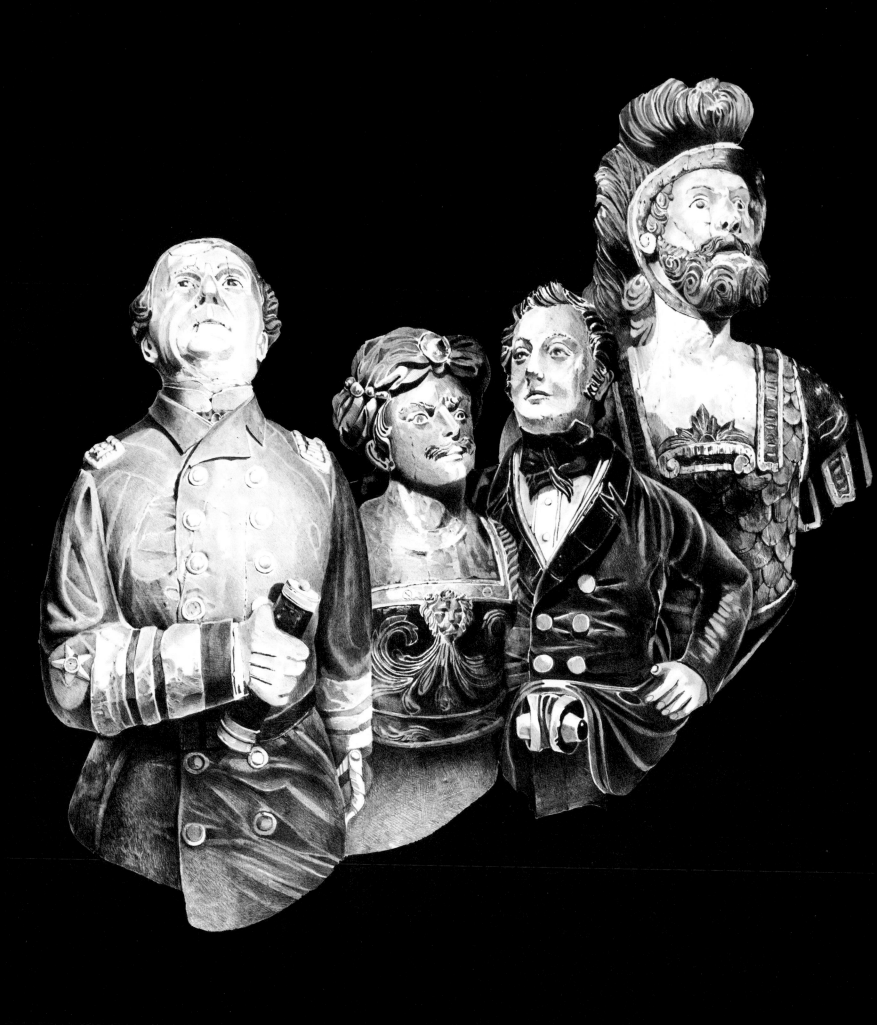

manag
the bu
take th
our wo
the ma
four of
again,
up the
now ic
standir
yards.
that I c
save m
beating
into ou
in a bu
boy, Ge
boy, fr
spritsai
black,"
but wh
to knoc
fisted tl
hauling
about a
snugly
be certa
our wat

I had l
clap
on de
other w
watch fc
steady
enough
give Ter
with snc
Cape He
this, anc
to make
the boor
halyards
the face
ropes sc
them. I v
trying tc
tack anc
through
struck, v
pot of h
better ye
in place c
frozen st

TWO YEARS BEFORE THE MAST

MONDAY, June 27th. 1836

During the first part of this day the wind continued fair, and, as we were going before it, it did not feel very cold, so that we kept at work on deck in our common clothes and round jackets. Our watch had an afternoon watch below for the first time since leaving San Diego; and, having inquired of the third mate what the latitude was at noon, and made our usual guesses as to the time she would need to be up with the Horn, we turned-in for a nap. We were sleeping away "at the rate of knots," when three knocks on the scuttle and "All hands, ahoy!" started us from our berths. What could be the matter? It did not appear to be blowing hard, and, looking up through the scuttle, we could see that it was a clear day overhead; yet the watch were taking in sail. We thought there must be a sail in sight, and that we were about to heave-to and speak her; and were just congratulating ourselves upon it — for we had seen neither sail nor land since we left port — when we heard the mate's voice on deck (he turned-in "all-standing," and was always on deck the moment he was called) singing out to the men who were taking in the studding-sails, and asking where his watch was. We did not wait for a second call, but tumbled up the ladder; and there, on the starboard bow, was a bank of mist, covering sea and sky, and driving directly for us. I had seen the same before in my passage round in the *Pilgrim*, and knew what it meant, and that there was no time to be lost. We had nothing on but thin clothes, yet there was not a moment to spare, and at it we went.

The boys of the other watch were in the tops, taking in the topgallant studding-sails, and the lower and topmast studding-sails were coming down by the run. It was nothing but "haul down and clew up." until we got all the studding-sails in, and the royals, flying-jib, and mizzen-topgallant sail furled, and the ship kept off a little, to take the squall. The fore and main topgallant sails were still on her, for the "old man" did not mean to be frightened in broad daylight, and was determined to carry sail till the last minute. We all stood waiting for its coming, when the first blast showed us that it was not to be trifled with. Rain, sleet, snow, and wind enough to take our breath from us, and make the toughest turn his back to windward! The ship lay nearly over upon her beam-ends; the spars and rigging snapped and cracked; and her topgallant masts bent like whipsticks. "Clew up the fore and main topgallant sails!" shouted the captain, and all hands sprang to the clewlines. The decks were standing nearly at an angle of forty-five degrees, and the ship going like a mad steed through the water, the whole forward part of her in a smother of foam.

This sudden turn, for which we were so little prepared, was as unacceptable to me as to any of the rest; for I had been troubled for several days with a slight toothache, and this cold weather and wetting and freezing were not the best things in the world for it. I soon found that it was getting strong hold, and running over all parts of my face; and before the watch was out I went to the mate, who had charge of the medicine-chest, to get something for it. But the chest showed like the end of a long voyage, for there was nothing that would answer but a few drops of laudanum, which must be saved for an emergency; so I had only to bear the pain as well as I could.

When we went on deck at eight bells, it had stopped snowing, and there were a few stars out, but the clouds were still black, and it was blowing a steady gale. Just before midnight, I went aloft and sent down the mizzen-royal yard, and had the good luck to do it to the satisfaction of the mate, who said it was done "out of hand and ship-shape." The next four hours below were but little relief to me, for I lay awake in my berth the whole time, from the pain in my face, and heard every bell strike, and, at four o'clock, turned out with the watch, feeling little spirit for the hard duties of the day. Bad weather and hard work at sea can be borne up against very well if one only has spirit and health; but there is nothing brings a man down at such a time, like bodily pain and want of sleep. There was, however, too much to do to allow time to think; for the gale of yesterday, and the heavy seas we met with a few days before, while we had yet ten degrees more southing to make, had convinced the captain that we had something before us which was not to be trifled with, and orders were given to send down the long topgallant masts. The topgallant and royal yards were accordingly struck, the flying-jib-boom rigged in, and the topgallant masts sent down on deck, and all lashed together by the side of the long-boat. The rigging was then sent down and coiled away below, and everything made snug aloft. There was not a sailor in the ship who was not rejoiced to see these sticks come down; for, so as the yards were aloft, on the least sign of a lull, the topgallant sails were loosed, and then we had to furl them again in a snow-squall, and *shin* up and down single ropes caked with ice, and send royal yards down in the teeth of a gale coming right from the south pole. It was an interesting sight, too, to see our noble ship dismantled of all her tophamper of long tapering masts and yards, and boom pointed with spear head, which ornamented her in port; and all that canvas which, a few days before, had covered her like a cloud, from the truck to the water's edge, spreading far out beyond her hull on either side, now gone; and she stripped like a wrestler for the fight. It corresponded, too, with the desolate character of her situation — alone, as she was, battling with storms, wind, and ice, at this extremity of the globe, and in almost constant night.

RICHARD HENRY DANA

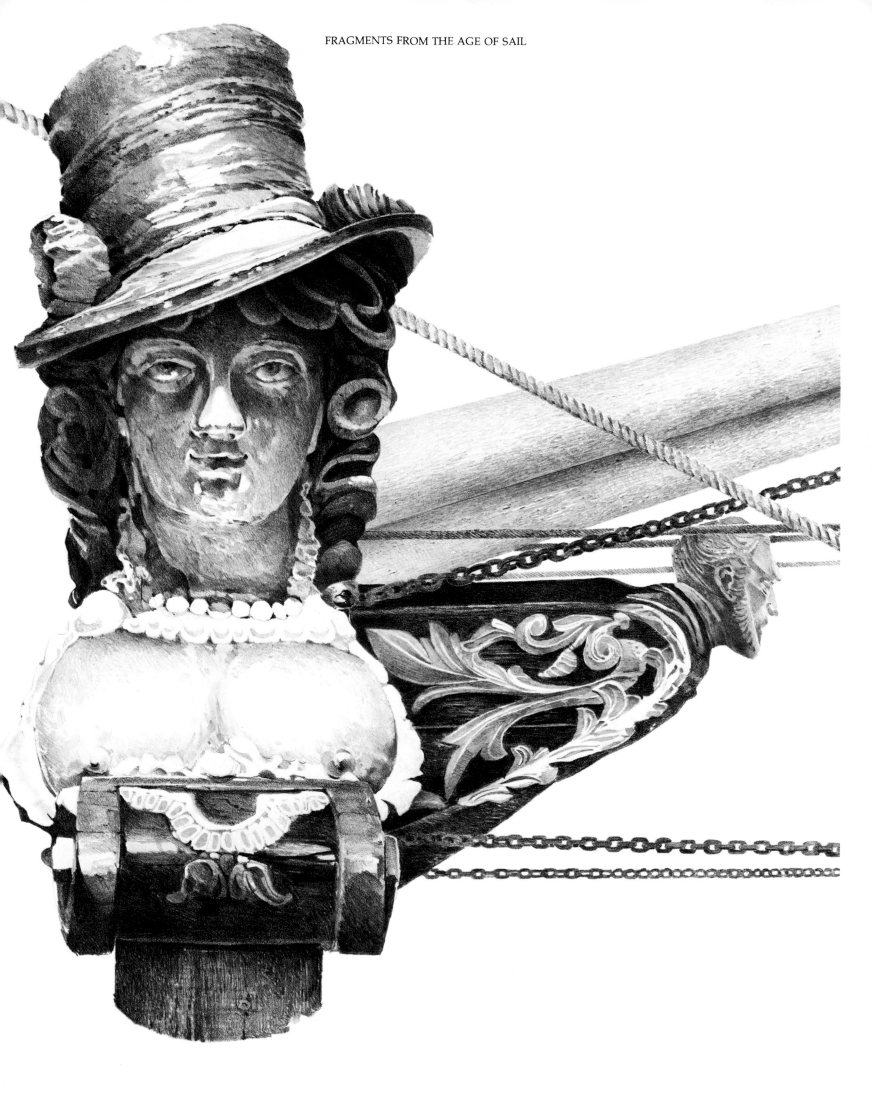

THE SHAMAN

Alariak told me about his journeys to the bottom of the sea. Whenever people in the camp were hungry he'd go underwater to reach the beautiful lady at the bottom of the sea and find food. When the shaman made this journey he'd have to sing songs to his spirit.

The path to the bottom of the sea was very dangerous with smooth and very slippery ice. The reason the shaman went was to bring the animals close to where the hunters were. Along the journey there were many animals. And all around the beautiful lady the animals were thick as flies. They looked like a mass of insects clustered together. This lady had so many animals — the usual animals, most of them food animals, the sea animals and, yes, the tuktu, too. All kinds of animals. She was the goddess of the animals.

After Alariak had made this journey, the men would go out hunting and they would find food. Alariak didn't actually get the food from the lady—the men would go hunting and they would find food. The men had to hunt for it but they would catch food for sure.

PETER PITSEOLAK

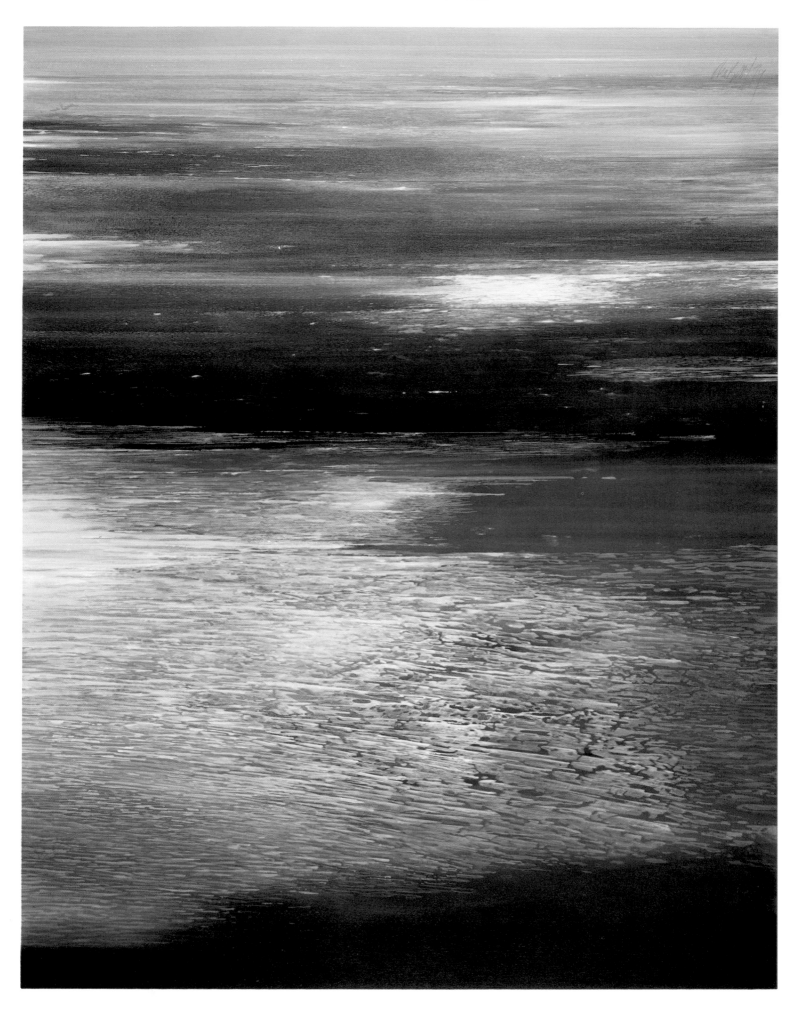

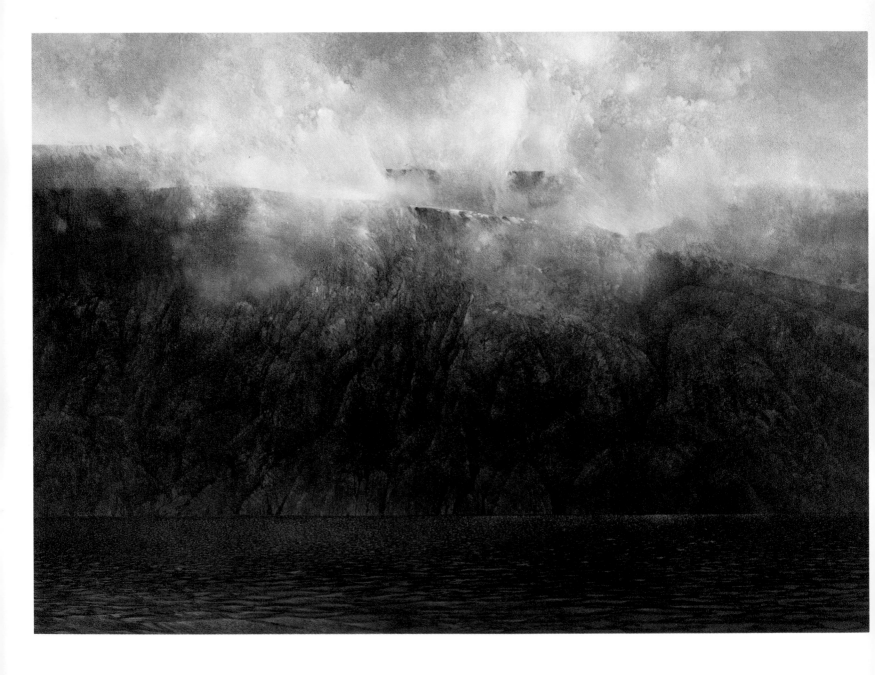

IN MEMORIAM

INGVALD BJORNDAL AND HIS COMRADE

Translation of a letter written somewhere in the North Atlantic and sent to the Government of Canada by Inspector Ovide Hubert of Cap-aux-Meules, Magdalen Islands. The letter was written in Norwegian and had been found in a bottle by the sea near l'Étang du Nord by Hubert Duclos, a fisherman, on 25 November 1940. The letter was addressed to Lovise Stigen, Kalandeendet (?) Fana.

While we sail and laugh, joke and fight, comes death
And it is the end. A man toils on board;
His life drifts away like a puff of breath;
Who will know his dreams now when the sea roared?
I loved you, my dear, but now I am dead,
So take somebody else and forget me.
My brothers, I was foolish, as you said:
So are most who place their fate in the sea.
Many tears have you shed for me in vain.
Take my pay, Mother, Father, I have come
A long way to die in the blood and rain.
Buy me some earth in the graveyard at home.
Goodbye. Please remember me with these words
To the green meadows and the blue fjords.

MALCOLM LOWRY

THE SERMON

There was a low rumbling of heavy sea-boots among the benches, and a still slighter shuffling of women's shoes, and all was quiet again, and every eye on the preacher.

"Shipmates, this book, containing only four chapters — four yarns—is one of the smallest strands in the mighty cable of the Scriptures. Yet what depths of the soul does Jonah's deep sealine sound! what a pregnant lesson to us is this prophet! What a noble thing is that canticle in the fish's belly! How billow-like and boisterously grand! We feel the floods surging over us; we sound with him to the kelpy bottom of the waters; sea-weed and all the slime of the sea is about us! But *what* is this lesson that the book of Jonah teaches? Shipmates, it is a two-stranded lesson; a lesson to us all as sinful men, and a lesson to me as a pilot of the living God. As sinful men, it is a lesson to us all, because it is a story of the sin, hard-heartedness, suddenly awakened fears, the swift punishment, repentance, prayers, and finally the deliverance and joy of Jonah. As with all sinners among men, the sin of this son of Amittai was in his wilful disobedience of the command of God — never mind now what that command was, or how conveyed — which he found a hard command. But all the things that God would have us do are hard for us to do — remember that — and hence, he oftener commands us than endeavors to persuade. And if we obey God, we must disobey ourselves; and it is in this disobeying ourselves, wherein the hardness of obeying God consists.

Shipmates, I do not place Jonah before you to be copied for his sin but I do place him before you as a model for repentance. Sin not; but if you do, take heed to repent of it like Jonah."

While he was speaking these words, the howling of the shrieking, slanting storm without seemed to add new power to the preacher, who, when describing Jonah's sea-storm, seemed tossed by a storm himself. His deep chest heaved as with a ground-swell; his tossed arms seemed the warring elements at work; and the thunders that rolled away from off his swarthy brow, and the light leaping from his eye, made all his simple hearers look on him with a quick fear that was strange to them.

There now came a lull in his look, as he silently turned over the leaves of the Book once more; and, at last, standing motionless, with closed eyes, for the moment, seemed communing with God and himself.

But again he leaned over towards the people, and bowing his head slowly, with an aspect of the deepest yet manliest humility, he spake these words:

"Shipmates, God has laid but one hand upon you; both his hands press upon me. I have read ye by what murky light may be mine the lesson that Jonah teaches to all sinners; and therefore to ye, and still more to me, for I am a greater sinner than ye. And now how gladly would I come down from this mast-head and sit on the hatches there where you sit, and listen as you listen, while some one of you reads *me* that other and more awful lesson which Jonah teaches to *me*, as a pilot of the living God. How being an anointed pilot-prophet, or speaker of true things, and bidden by the Lord to sound those unwelcome truths in the ears of a wicked Nineveh, Jonah, appalled at the hostility he should raise, fled from his mission, and sought to escape his duty and his God by taking ship at Joppa. But God is everywhere; Tarshish he never reached. As we have seen, God came upon him in the whale, and swallowed him down to living gulfs of doom, and with swift slantings tore him along 'into the midst of the seas,' where the eddying depths sucked him ten thousand fathoms down, and the weeds were wrapped about his head,' and all the watery world of woe bowled over him. Yet even then beyond the reach of any plummet—'out of the belly of hell'— when the whale grounded upon the ocean's utmost bones, even then, God heard the engulphed, repenting prophet when he cried. Then God spake unto the fish; and from the shuddering cold and blackness of the sea, the whale came breeching up towards the warm and pleasant sun, and all the delights of air and earth; and 'vomited out Jonah upon the dry

land;' when the word of the Lord came a second time; and Jonah, bruised and beaten—his ears, like two sea-shells, still multitudinously murmuring of the ocean — Jonah did the Almighty's bidding. And what was that, shipmates? To preach the Truth to the face of Falsehood! That was it!

"This, shipmates, this is that other lesson; and woe to that pilot of the living God who slights it. Woe to him whom this world charms from Gospel duty! Woe to him who seeks to pour oil upon the waters when God has brewed them into a gale! Woe to him who seeks to please rather than to appal! Woe to him whose good name is more to him than goodness! Woe to him who, in this world, courts not dishonor! Woe to him who would not be true, even though to be false were salvation! Yea, woe to him who, as the great Pilot Paul has it, while preaching to others is himself a castaway!"

He drooped and fell away from himself for a moment; then lifting his face to them again, showed a deep joy in his eyes, as he cried out with a heavenly enthusiasm, — "But oh! shipmates! on the starboard hand of every woe, there is a sure delight; and higher the top of that delight, than the bottom of the woe is deep. Is not the maintruck higher than the kelson is low? Delight is to him—a far, far upward, and inward delight —who against the proud gods and commodores of this earth, ever stands forth his own inexorable self. Delight is to him whose strong arms yet support him, when the ship of this base treacherous world has gone down beneath him. Delight is to him, who gives no quarter in the truth, and kills, burns, and destroys all sin though he pluck it out from under the robes of Senators and Judges. Delight,—top-gallant delight is to him, who acknowledges no law or lord, but the Lord his God, and is only a patriot to heaven. Delight is to him, whom all the waves of the billows of the seas of boisterous mob can never shake from this sure Keel of the Ages. And eternal delight and deliciousness will be his, who coming to lay him down, can say with his final breath — O Father! — chiefly know to me by Thy rod—mortal or immortal, here I die. I have striven to be Thine, more than to be this world's, or mine own. Yet this is nothing; I leave eternity to Thee; for what is man that he should live out the lifetime of his God?"

He said no more, but slowly waving a benediction, covered his face with his hands, and so remained kneeling, till all the people had departed, and he was left alone in the place.

HERMAN MELVILLE

PSALM 107

23 They that go down to the sea in ships, that do business in great waters.

24 These see the works of the LORD, and his wonders in the deep.

25 For he commandeth, and raised the stormy wind, which lifteth up the waves thereof.

26 They mount up to the heaven, they go down again to the depths: their soul is melted because of trouble.

27 They reel to and fro, and stagger like a drunken man, and are at their wit's end.

28 Then they cry unto the LORD in their trouble, and he bringeth them out of their distresses.

29 He maketh the storm a calm, so that the waves thereof are still.

30 Then are they glad because they be quiet; so he bringeth them unto their desired haven.

31 Oh that *men* would praise the LORD *for* his goodness, and *for* his wonderful works to the children of men!

32 Let them exalt him also in the congregation of the people, and praise him in the assembly of the elders.

SONG TO THE SEA

After mourning ceased on the third day following a death, the hunters set out again on a kayak journey. To ensure fine weather, the leader sang and the others replied—

Poor it is: this land,
Poor it is: this ice,
Poor it is: this air,
Poor it is: this sea,
Poor it is.

ARCTIC BURIAL

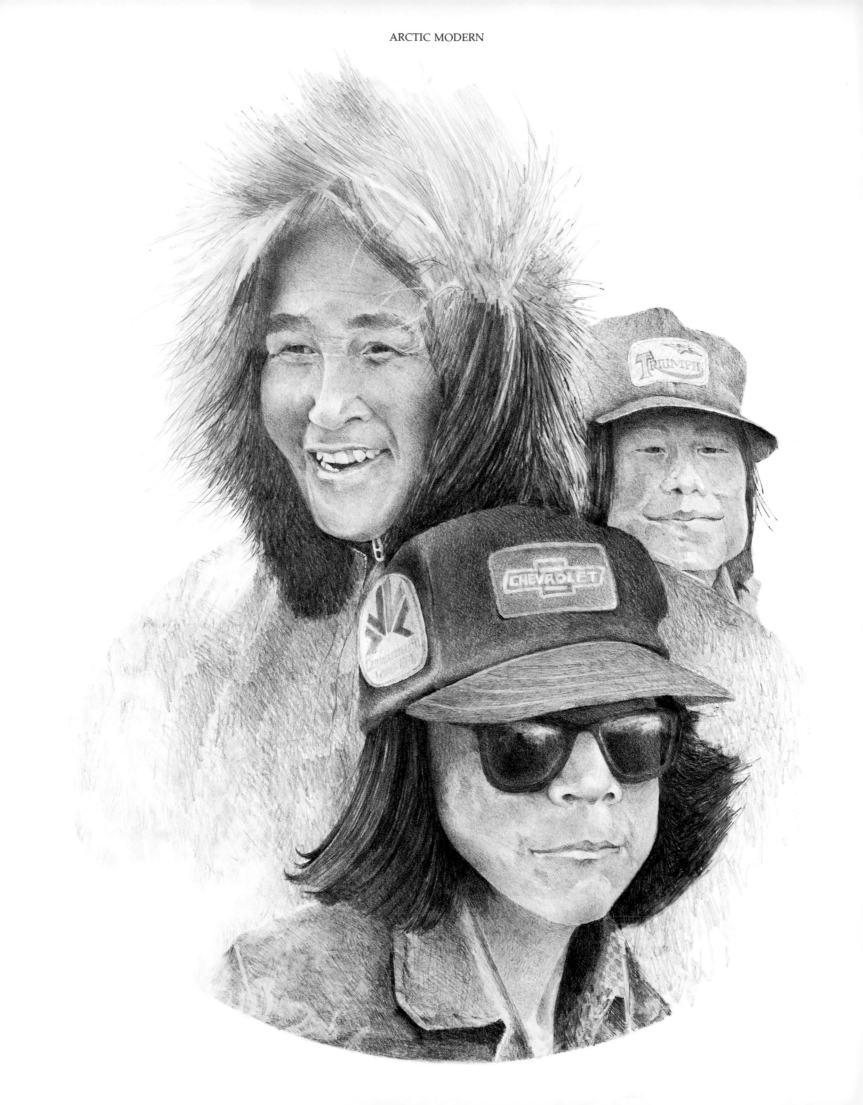

THE SEAL

Near the turn of the century, Taptunak, his wife and children were living in a tiny igloo on the shores of the Arctic Ocean. Winter was hard upon them. They were hungry. Taptunak could not go sealing in the blizzard that howled around them. He had to wait for the weather to calm and while he waited his family grew hungrier and hungrier. He waited seven whole days before the blizzard blew itself out. It was the eighth day after the storm had started that Taptunak crawled out of the igloo and, seeing the change in the weather, hurried back in to prepare for the seal hunt.

"You can come with me, today," he said to Alekak, his eldest son. "We will go after seals together."

"Good," said Alekak and smiled.

It was a great thrill for a twelve year old boy to go hunting.

"One day," thought Alekak, as he got dressed, "I'm going to be as great a hunter as my father."

They dressed warmly and, with harpoons in hand, went out onto the sea ice.

Taptunak knew exactly where to go. Before the blizzard had overtaken them he had noticed two breathing holes. Alekak followed his father. He moved cumbersomely in his furs but he was glad to be outside, glad to be with his father and glad to be hunting. It did not take them long to reach the first breathing hole.

"Wait here, my son," said Taptunak. "Watch carefully. Strike hard and good luck to you."

Alekak prepared to wait as his father went to another breathing hole a few hundred yards away. He could not see where his father stood for he was hidden from view by the hummocked ocean ice.

Straining his ears, Alekak half crouched over the seal hole with harpoon poised. He was waiting to hear the barely audible approach of his quarry. Young boy that he was, he knew the ways of the seal. He knew its need to breathe and he knew what sound to listen for. Excited, yet motionless, he waited. In one hand was the harpoon and in the other the rope. The rope was attached to the barb that would separate from the shaft of the weapon when it struck into the seal.

Alekak had not been waiting long when he heard a barely audible lap followed by the sound of seal breathing. His muscles tightened. He raised high the harpoon and struck down firmly in the centre of the hole. He struck well and true — the seal was hooked. Then the battle began. Straining with all his strength he tried to drag the wounded animal onto the ice.

"It's a big one," he said to himself. "It's a big one."

He braced himself in all sorts of ways but could not lift the animal. The seal fought and Alekak fought. He called for his father but his father did not come. The seal was too big for

Alekak. He knew he would never lift it from the ocean. As he fought, the rope tangled itself around him and he could not get free. Inexorably, he was drawn down into the hole by the seal that would not die.

"I cannot. I cannot," he cried. "I cannot hold him..."

Alekak was gone. The seal had won. The little hunter was dead but still Taptunak waited. Never stirring, ever listening, patiently poised, he waited. Hours passed. Still he waited. Occasionally he would wonder how Alekak was but he knew he was a good, dependable boy.

Suddenly, Taptunak stiffened almost imperceptibly. He had heard a seal. Silently, he drew himself up. Then, as the seal gulped air, he thrust with his harpoon. It was the stroke of an expert and right on the target. Taptunak began to pull on the rope and as he did he realized he had struck a feast indeed. He knew immediately that this was no ordinary seal but a great big square flipper. Usually one seal would only mean one hundred pounds of meat but a square flipper would yield, perhaps, as much as seven hundred pounds. This was his lucky day. With the well aimed thrust of the harpoon he had killed the beast. Now he had to haul it onto the ice. He knew he would need help so he called for his son.

"Alekak. Alekak. Alekak."

There was no answer.

"A...le...ka...k. A...le...ka...k. A...le...ka...k."

Still no answer.

Taptunak shook his head and settled down to the struggle. Finally, he managed to slither it out onto the ice. It was a proud moment for Taptunak. His wife would be pleased. His children would congratulate him. Weary from his exertions, Taptunak looked the beast over.

"What's that?" he murmured, and taking a closer look he saw a rope hanging from the seal. Quickly, he felt for the head of harpoon and sure enough, there it was. Taptunak pulled on the rope. It was not hard to pull. He knew what it was and yet ...and yet, he hoped he was wrong. Slowly the rope coiled at his feet.

"Alekak, Alekak," he murmured, as the body of his son slipped out of the icy water and lay stretched beside the seal.

RAY PRICE

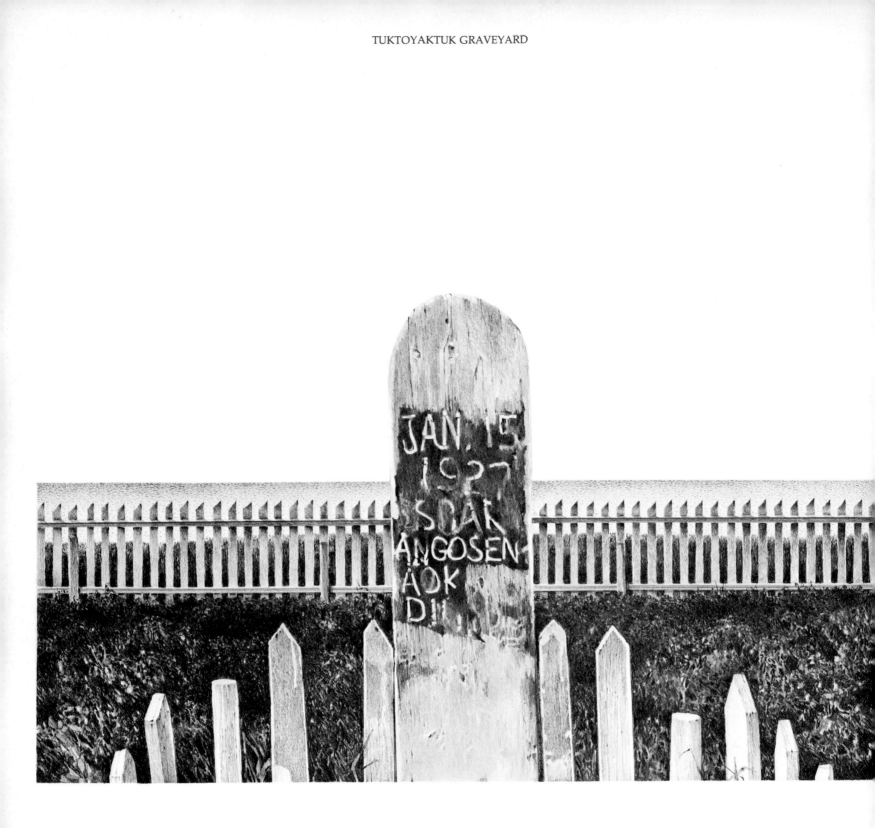

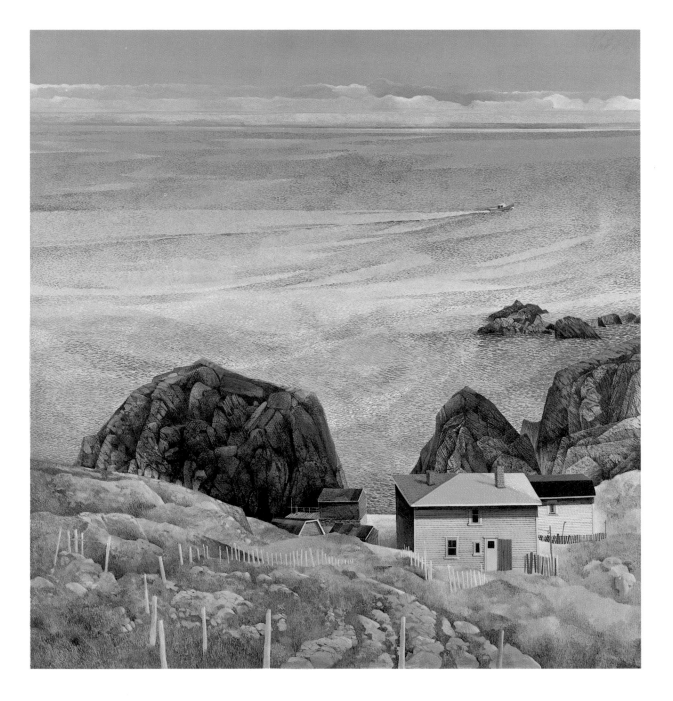

THE RETURN OF THE GOLDEN SHELL

RIDERS TO THE SEA

Scene. An Island off the West of Ireland. Cottage kitchen, with nets, oilskins, spinning-wheel, some new boards standing by the wall.

MAURYA I've had a husband, and a husband's father, and six sons in this house — six fine men, though it was a hard birth I had with every one of them and they coming to the world — and some of them were found and some of them were not found, but they're gone now the lot of them... There were Stephen, and Shawn, were lost in the great wind, and found after in the Bay of Gregory of the Golden Mouth, and carried up the two of them on the one plank, and in by that door. *(She pauses for a moment, the girls start as if they heard something through the door that is half open behind them.)*

NORA *(in a whisper).* Did you hear that, Cathleen? Did you hear a noise in the north-east?

CATHLEEN *(in a whisper).* There's some one after crying out by the seashore.

MAURYA *(continues without hearing anything).* There was Sheamus and his father, and his own father again, were lost in a dark night, and not a stick or sign was seen of them when the sun went up. There was Patch after was drowned out of a curagh that turned over. I was sitting here with Bartley, and he a baby, lying on my two knees, and I seen two women, and three women, and four women coming in, and they crossing themselves, and not saying a word. I looked out then, and there were men coming after them, and they holding a thing in the half of a red sail, and water dripping out of it — it was a dry day, Nora — and leaving a track to the door. *(She pauses again with her hand stretched out towards the door. It opens softly and old women begin to come in, crossing themselves on the*

threshold, and kneeling down in front of the stage with red petticoats over their heads.)

MAURYA *(half in a dream, to* CATHLEEN). Is it Patch, or Michael, or what is it at all?

CATHLEEN Michael is after being found in the far north, and when he is found there how could he be here in this place?

MAURYA There does be a power of young men floating round in the sea, and what way would they know if it was Michael they had, or another man like him, for when a man is three days in the sea, and the wind blowing, it's hard set his own mother would be to say what man was it.

CATHLEEN It's Michael, God spare him, for they're after sending us a bit of his clothes from the far north. *(She reaches out and hands* MAURYA *the clothes that belonged to* MICHAEL. MAURYA *stands up slowly, and takes them in her hands.* NORA *looks out.)*

NORA They're carrying a thing among them and there's water dripping out of it and leaving a track by the big stones.

CATHLEEN *(in a whisper to the women who have come in).* Is it Bartley it is?

ONE OF THE WOMEN It is surely, God rest his soul.

(Two younger women come in and pull out the table. Then men carry in the body of BARTLEY, *laid on a plank, with a bit of a sail over it, and lay it on the table.)*

CATHLEEN *(to the women, as they are doing so).* What way was he drowned?

ONE OF THE WOMEN The gray pony knocked him into the sea, and he was washed out where there is a great surf on the white rocks.

*(*MAURYA *has gone over and knelt down at the head of the table. The women are keening softly and swaying themselves with a slow movement.* CATHLEEN *and* NORA *kneel at the other end of the table. The men kneel near the door.)*

MAURYA *(raising her head and speaking as if she did not see the people around her).* They're all gone now, and there isn't anything more the sea can do to me ... I'll have no call now to be up crying and praying when the wind breaks from the south, and you can hear the surf is in the east, and the surf is in the west, making a great stir with the two noises, and they hitting one on the other. I'll have no call now to be going down and getting Holy Water in the dark nights after Samhain, and I won't care what way the sea is when the other women will be keening. *(To* NORA) Give me the Holy Water, Nora, there's a small sup still on the dresser.

*(*NORA *gives it to her.)*

MAURYA *(drops* MICHAEL'S *clothes across* BARTLEY'S *feet, and sprinkles the Holy Water over him).* It isn't that I haven't prayed for you, Bartley, to the Almighty God. It isn't that I haven't said prayers in the dark night till you wouldn't know what I'ld be saying; but it's a great rest I'll have now, and it's time surely. It's a great rest I'll have now, and great sleeping in the long nights and great sleeping in the long nights after Samhain, if it's only a bit of wet flour we do have to eat, and maybe a fish that would be stinking. *(She kneels down again, crossing herself, and saying prayers under her breath.)*

CATHLEEN *(to an old man).* Maybe yourself and Eamon would make a coffin when the sun rises. We have fine white boards herself bought, God help her, thinking Michael would be found, and I have a new cake you can eat while you'll be working.

THE OLD MAN *(looking at the boards).* Are there nails with them?

CATHLEEN There are not, Colum; we didn't think of the nails.

ANOTHER MAN It's a great wonder she wouldn't think of the nails, and all the coffins she's seen made an ready.

CATHLEEN It's getting old she be and broken.

*(*MAURYA *stands up again very slowly and spreads out the pieces of* MICHAEL'S *clothes beside the body, sprinkling them with the last of the Holy Water.)*

NORA *(in a whisper to* CATHLEEN). She's quiet now and easy; but the day Michael was drowned you could hear her crying out from this to the spring well. It's fonder she was of Michael, and would any one have thought that?

CATHLEEN *(slowly and clearly).* An old woman will be soon tired· with anything she will do, and isn't it nine days herself is after crying and keening, and making great sorrow in the house?

MAURYA *(puts the empty cup mouth downwards on the table, and lays her hands together on* BARTLEY'S *feet).* They're all together this time, and the end is come. May the Almighty God have mercy on Bartley's soul, and on Michael's soul, and on the souls of Sheamus and Patch, and Stephen and Shawn *(bending her head)*; and may He have mercy on my soul, Nora, and on the soul of every one is left living in the world. *(She pauses, and the keen rises a little more loudly from the women, then sinks away.)*

MAURYA *(continuing).* Michael has a clean burial in the far north, by the grace of the Almighty God. Bartley will have a fine coffin out of the white boards, and a deep grave surely. What more can we want than that? No man at all can be living for ever, and we must be satisfied. *(She kneels down again and the curtain falls slowly.)*

J.M. SYNGE

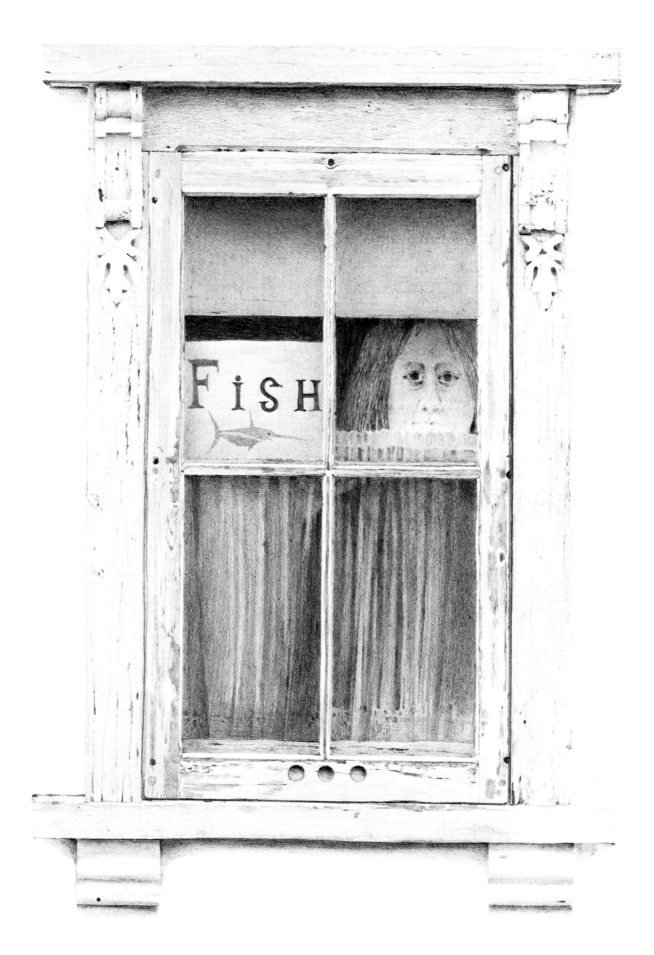

THE SILENCE of nature is a conflicting silence from the human point of view. It is a blessed silence because it gives man an intuitive feeling of the great silence that was before the word and out of which everything arose. And it is oppressive at the same time because it puts man back into the state in which he was before the creation of language; before the creation of man. It is like a threat that the word might be taken away from him again into that original silence.

If man were nothing but a part of nature, then he would never be solitary. He would always be connected with everything through silence — but in a relationship that would concern only the natural side of his nature. Man is not, however, only a part of nature, but also spirit, and the spirit is solitary when man is connected with things only through silence, for the spirit needs to be connected with things through the word. Then the spirit ceases to be solitary in the neighbourhood of silent nature: it speaks and is still in the silence. In fact through the word it can create silence. That is the sign of the divine origin of the word that out of it can arise the absolutely other, that which is not contained in the external givenness of the word: the unexpected silence.

The relation with things through silence is a permanent relationship, but the connection through the word is tied to the moment. But it is the moment of truth which appears in the word, and that is the moment of Eternity.

We have said that the silence of nature is permanent; it is the air in which nature breathes. The motions of nature are the motions of silence. The alternation of the seasons is the rhythm of silence; the pattern of the changing seasons is covered by silence.

The silence of nature is the primary reality. The things of nature serve only to make the silence clearly visible. The things of nature are images of the silence, exhibiting not themselves so much as the silence, like signs pointing to the place where silence is.

MAX PICARD

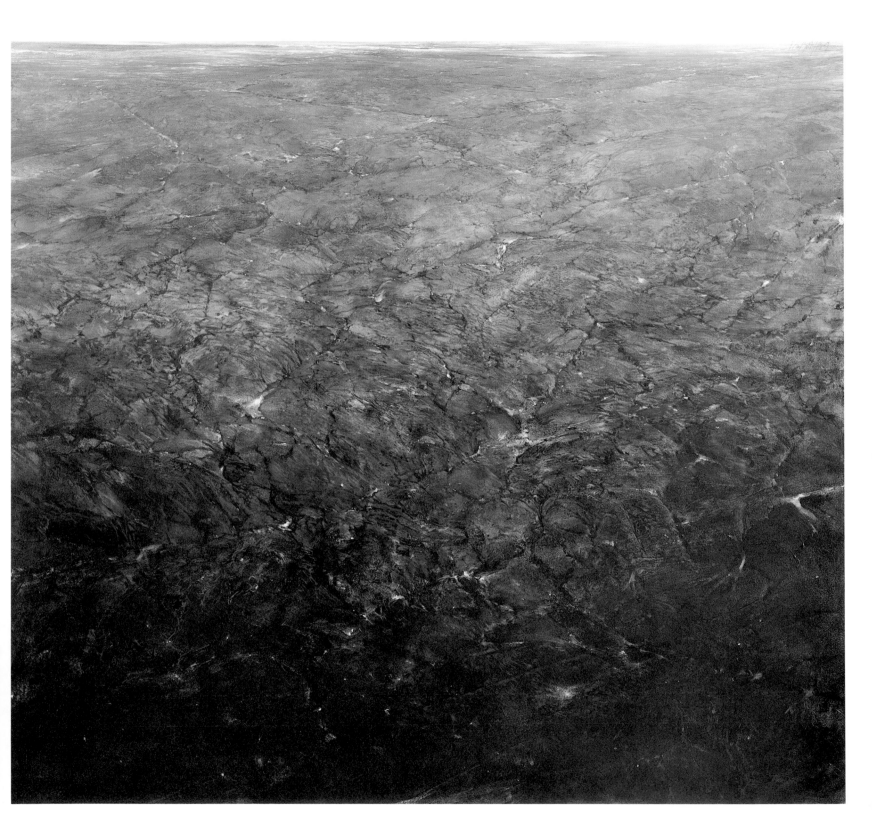

ARCTIC ONE—TOWARD THE POLAR SEAS

ATLANTIC DOOR

Through or over the deathless feud
of the cobra sea and the mongoose wind
you must fare to reach us
through hiss and throttle come
where the great ships are scattered twigs
on a green commotion
where the plane is a fugitive mote
in the stare of the sun

Come by a limbo of motion humbled
under cliffs of cloud
and over gargantuan whalehalls
In this lymph's abyss a billion
years of spawning and dying have passed
and will pass without ministration of man

For all the red infusions of sailors
veins of vikings lost and matelots
haemoglobin of Gilbert's hearties and Jellicoe's
for all blood seeping from corvette and sealer
from sodden hulls of Hood and Titanic
still do these waves when the gale snaps them
fracture white as the narwhal's tusk

Come then trailing whatever pattern
of gain or solace and think no more than you must
of the simple unhuman truth of this emptiness
that down deep below the lowest pulsing
of primal cell
tar-dark and dead
lie the bleak and forever capacious tombs of the sea

Grand Banks 1945

EARLE BIRNEY

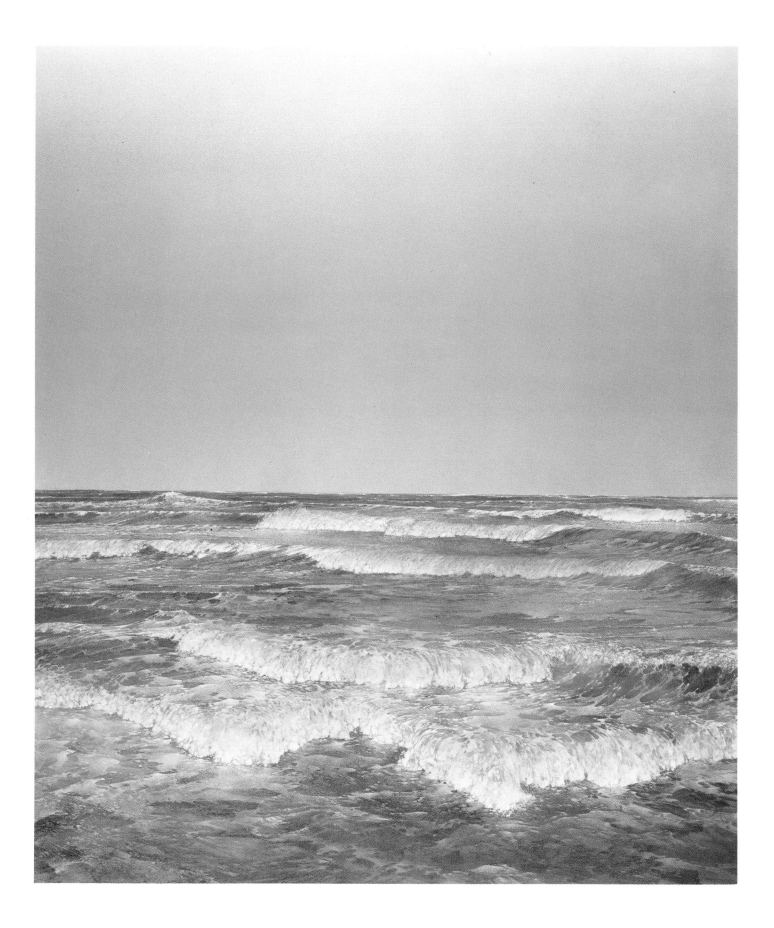

MORNING, NORTH SEA

GULF OF GEORGIA

Come where the seal in a silver sway
 like the wind through grass
goes blowing balloons behind him

Lie where the breakers are crashing like glass
 on the varnished sand
writing their garrulous arabic

Dive from the shining fluted land
 through the water's mesh
to the crab's dark flower and the starfish

Trail the laggard fins of your flesh
 in the world's lost home
and wash your mind of its landness

Off Point Atkinson, Vancouver 1945

EARLE BIRNEY

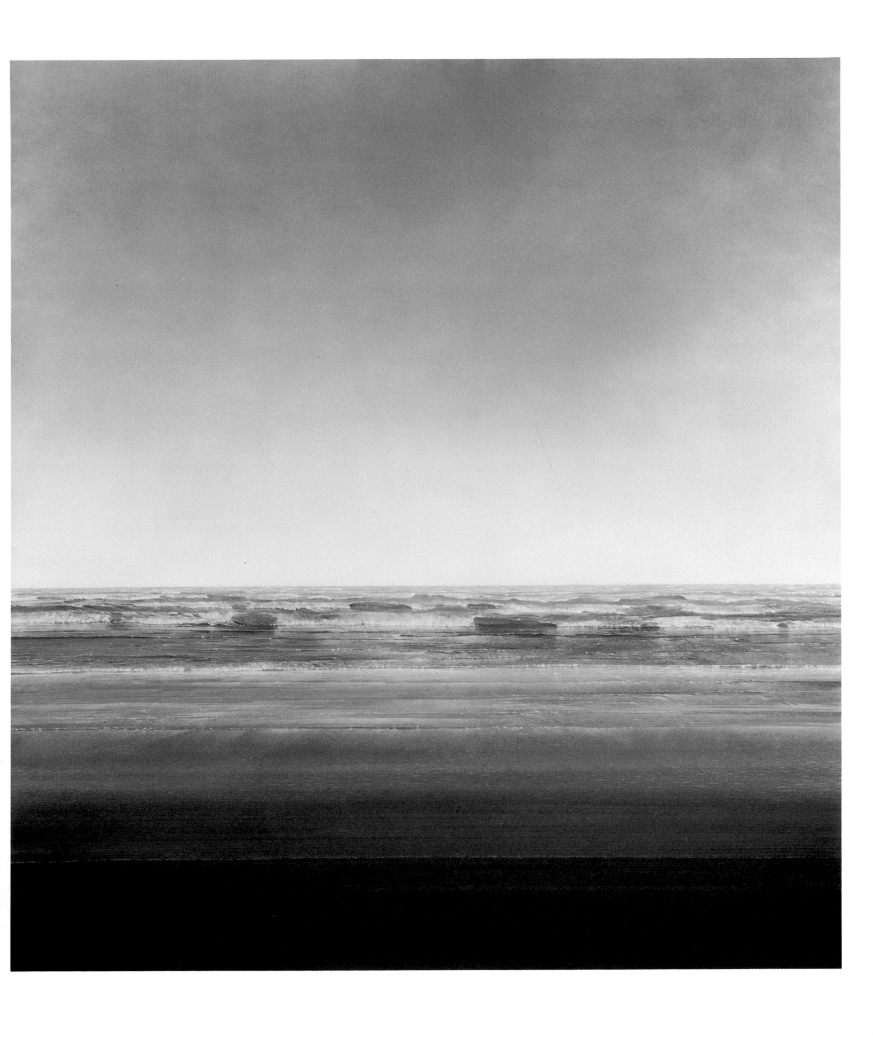

Sitting staring out into the blue Pacific, which ran without a clear transition into blue space, I felt that the ocean was immense, endless, bottomless. There was something beyond human comprehension about its immeasurable size, since the Amazon, the Nile, the Danube, the Mississippi, the Ganges, all the rivers, floods, and sewers in the world could enter into it ceaselessly without the surface level ever changing an inch. All the running water in the world heads for the ocean, yet it only churns its currents around as in a witch's caldron, its surface calmly rising and sinking with the tides, ignoring the fact that it ought to overflow, that it ought to run slowly into our cave and start rising up the cliff wall behind us. All the rain and all the rivers have no effect on its level. All the mud, the silt, the rotting vegetation, the carcasses and excrement of animals from sea, air, and land that have washed into it since the days of the dinosaurs and the first life on earth have failed to pollute it and have left it perfectly clean. For man, the sea and the sky have been the two symbols of endless dimensions and permanence.

This was my subconscious feeling about the boundless masses of water in front of me as we sat in the cave and saw how it merged into the vault of heaven as part of blue space. Although my textbooks had told me its width in miles and its depth in feet, and although I knew the secrets of its permanence, I was still sitting there like illiterate Polynesians before me, and Europeans in medieval times, feeling that the land was man's domain but that the ocean was part of space.

How wrong I was. And how much I had to wrestle with the world ocean before I changed my view completely, before I saw it as the pulsating heart of our own living biosphere. As a nonstop mechanism, running like a pump and filter to our own world, although innocently camouflaged as an immense watery waste with no beginning and no end, I still had to discover that the biggest ocean can be crossed by landlubbers in the smallest craft, before I realized the true dimensions of the ocean. The buildings of downtown New York would rise high above sea level if placed on the bed of the North Sea, and

the average depth of all oceans amounts to about five thousand feet, the distance covered by a runner in less than four minutes. If the ocean were to be represented in its true proportions on a normal globe, no blue paint could be smeared on in a coat thin enough to give the proper dimensions. In this water, nearly all life is concentrated near the very upper layer, which is penetrated by the life-giving rays of the sun.

The ocean is just another lake. It has no beginning and no end, but neither has an apple. Its surface just curves and meets itself. It does not overflow, because the rain and the rivers that run into it amount, to the ounce, to the quantity that evaporates from its surface and returns once more by way of the clouds. It has never turned filthy, because nature, unlike modern man, has carefully avoided putting its own atoms together to form molecules that bacteria and plankton could not transform into useful new life. Nature, with all its mud, carcasses, and excrement, could go on using its rivers as sewers forever.

The ocean was there with its millions of inhabitants to filter all the water that reached it and transform the waste into new organisms ready to continue the filtration, sending only purified, clean water back to land by way of the clouds. Man has started to throw loose bolts and nuts into an already functioning and perfect *perpetuum mobile*. Plastics, insecticides, detergents, and other combinations of molecules that nature wisely ignored so as not to plug up the machinery, now arrive and remain. We were to see visible pollution floating past our reed bundles every day when the papyrus boat *Ra II* crossed the Atlantic in 1970. We sailed past tar-like clots of oil forty-three days out of the fifty-seven the crossing lasted. Earlier, in 1947, we had sailed in perfectly pure water from Peru to Polynesia on the *Kon-Tiki* raft. We found no pollution then, although we sifted the sea water by towing behind us a fine-meshed plankton net.

THOR HEYERDAHL

ON THE BEACH AT NIGHT ALONE

On the beach at night alone,
As the old mother sways her to and fro singing her husky song,
As I watch the bright stars shining, I think a thought of the clef of
the universes and of the future.

A vast similitude interlocks all,
All spheres, grown, ungrown, small, large, suns, moons, planets,
All distances of place however wide,
All distances of time, all inanimate forms,
All souls, all living bodies though they be ever so different, or in different worlds,
All gaseous, watery, vegetable, mineral processes, the fishes, the brutes,
All nations, colors, barbarisms, civilizations, languages,
All identities that have existed or may exist on this globe, or any globe,
All lives and deaths, all of the past, present, future,
This vast similitude spans them, and always has spann'd,
And shall forever span them and compactly hold and enclose them.

WALT WHITMAN

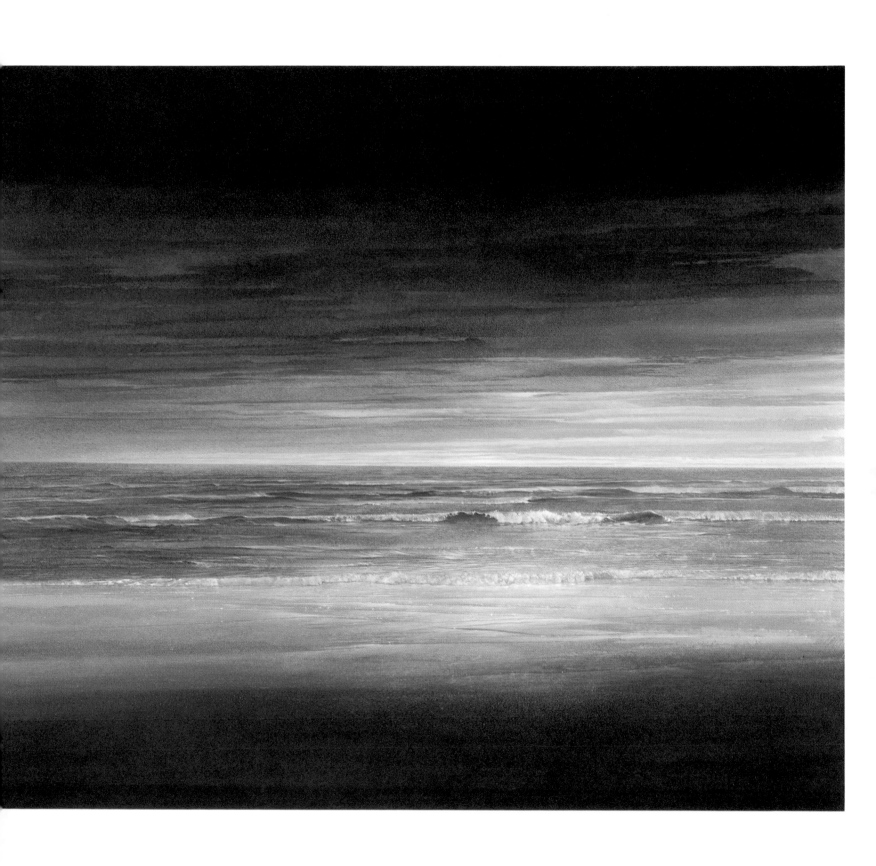

RON BOLT

AN APPRECIATION

BY GLEN E. CUMMING

A frozen wave is caught just before it explodes ashore to meld with sand and pebbles. A tranquil sea is depicted under a gigantic sky that one only sees in the Caribbean. Images found in the paintings of artist Ron Bolt are not created in St. John's, with the salt spray slashing his face, or Cartegena, with the foam frothing at his feet, but on good old Toronto terra-ferma, three floors up in his comfortable studio-home. Yet, the works produced there (34 drawings and 24 paintings), have the ring of truth. The taste and smell of the sea is apparent. I try to reconcile the Maritime works in front of me with the view from his studio windows: a suburban street to the east, a high school with students running and playing games in a large field to the north. In some funny way, it helps when I remember that I had the same feeling only a few weeks earlier when I viewed the flat prairie-like landscapes produced by Takao Tanabe in his Banff studio facing the most unflat, unprairie-like landscape in the world, high in the Alberta Rockies. The studio is not the frame, but the workshop.

Bolt comes by his love for the sea honestly. His grandfather, an Anglican minister, ran a mission for fishermen in Hartlepool, northeast England. However, it was on a trip to Newfoundland in '72, and on another in '73, where meeting George Noseworthy, an American of Newfoundland parents and being influenced by David Blackwood, and Christopher Pratt, that he discovered the sea.

Initially, he tried to paint the crashing waves on location, but found it was impossible. Not surprising, when one considers the hopelessness of trying to paint the ever changing colour and shape of a split second of time, in acrylic paint, a medium which, though faster drying than oil, is by its very nature, still too slow. The result of such efforts, the artist candidly states, usually ended up as "mud".

At first, the artist's response to the sea was sensual, but he realized that control of the intellect was needed if he were to succeed in his work. Therefore, it seemed only logical that he take advantage of twentieth century technology, and so, he turned to the camera. Soon, he could be seen hanging over cliffs, jumping over rocks and pools, and shooting the reflections, waves, rocks and sky. Before long, Bolt had taken hundreds of colour slides and black and white photos. This process gave him valuable time to really look at and experience the sea without feeling the frantic urge to start painting. This communion with the sea helped Bolt back at his studio, where moods, colour and sound resurfaced in his mind to produce successful works.

Surrounded by his photographic work, Bolt projects the slides or portions of them he wishes to use on to a stretched canvas. He does not use a pencil to draw the projected slide images on his canvas, but rather, starts painting immediately and "locks in" a basic abstract composition of large areas of colour. To Bolt, the projected colour slide is of value for the first encounter in layout because it is used as an aid to capture the seminal idea in terms of abstract composition. He often employs a number of different techniques in rendering these areas of colour, and is able to dispense with this preliminary work quickly. Therefore, it is not uncommon for him to use rollers, spray guns, crumpled paper towels, or any other method in addition to the traditional artist's brush, which allow for speed of execution. Once the initial colour patterns and shapes have been painted in, he turns the projector off and begins to develop and refine the painting in front of him. From now on, he is free to let his imagination dictate the type of work he will produce, and with his brush, he starts to develop and probe the possibilities. Now and then, the artist must force himself to stop in order to contemplate and examine the direction of his work.

Sometimes, he will leave the painting on view in his studio while he starts work on previously unfinished canvases, or he will commence a new painting or drawing, so even though a painting may be in progress for several months before it is completed, the actual painting time might be as little as a few days.

If the paintings grow as a result of "living with them", the drawings, on the other hand, are more direct in that they are usually completed within a couple of days. For producing the drawings, he uses black and white photographs, and often selects images from several photographic sources to create compositions that are satisfactory to him. Most drawings are done on smooth paper with little or no tooth. The artist creates these works using a medium hard (2H) pencil for fine detail and light shading, and a medium soft (2B) pencil for darker, bolder areas, to attain the rich velvety quality found in many works. Many of these drawings are "photo-realistic" in a true sense of the word because they exploit the photograph in a more intellectual, more technically controlled manner than the paintings. The drawings are also of a size and format intimate, and comfortable, in which the technique, not as apparent as in the paintings, enhance their realistic affinity to the black and white photographs. The paintings, on the other hand, cannot be as easily classified as "photo-real", because no matter how realistic they appear at a distance, in closer proximity, they reveal too much love for the manipulation of paint, as evidenced in the brushwork.

The artist generally does not attempt to hide the use of the camera in his work. In one painting "First Morning", he exploits the camera as a source. We see light spots at the top, centre, and bottom of the painting which are clearly reflections from a bright sun onto the lense of the camera. Naturally, Bolt could have eliminated the reflection in his development of the painting, however, as he lived with the painting and worked at it over a period of time, the reflection caused by the camera lense became important to the work and was retained. This reflection tends to enhance and amplify the feeling of sun, sky and water, at once recognizable to anyone who has spent a summer by the coast or at the lake.

There is a distinctly Canadian use of colour in most of the sea pictures, expressed by the use of blues and greens and other colours at the cooler end of the spectrum associated with Canadian oceans; but in the paintings of southern seas, even though he employs warmer hues, the colour sensibility, one feels, is markedly different from the sensibility one would expect of an artist from that area.

In his creative development, Bolt has now come full circle. Working counterclockwise to most artists, he started his career as a commercial designer working largely with abstract shapes which still underly his work today. As his work progressed, these shapes took on aspects of the landscape. He then worked through from pure abstraction, to somewhat romantic depictions of mountains and wilderness areas, to a more intellectual realism combined with the strong design found in these recent seascapes. By using the photograph or slide as his "sketch", Bolt has the time on location to observe, to feel, to taste, to smell, to hear, and thus, to experience and meditate on his subject in a relaxed, creative way. He can store up in his mind the moods, the sights, the sounds and silences of the ocean, sky and land. And then months, even years later, in the cold reality of his studio, he must draw upon his reserves to give life to his work. The drawings and paintings presented here indicate he has done just that.

GLEN E. CUMMING
DIRECTOR
ART GALLERY OF HAMILTON

BIOGRAPHY

Ron Bolt was born in Toronto in 1938. He graduated as gold medallist from Northern Technical School in 1956 and apprenticed with the commercial art firm of Sherman Laws Limited in Toronto where he remained for six years. During that time he studied graphic design and typography while taking periodic courses at the Ontario Art College and Ryerson Polytechnical Institute. He completed his musical studies in 1961, receiving an Associateship in piano performance and teaching from the Royal Conservatory of Music.

From 1961 to 1971, Bolt worked in Toronto and London, England, as graphic designer and art director, engaged in all phases of advertising communications including print design and television production. His interest in painting continued apace with his commercial activities and in 1971 he had reached the stage where painting had become too important an activity to be carried on in the evenings and on weekends. Consequently, he decided to take a year away from the business world. He has been pursuing a full time career in fine art ever since.

His work in graphic design brought him several awards including two silver medals for design from the Canadian Packaging Institute and an Award of Distinctive Merit from the Graphica Exhibition, Montreal, 1971. His fine art credits begin in 1967.

1967
Ontario Society of Artists Open Exhibition, Art Gallery of Ontario (catalogue)

1969
Three man exhibition at Vincent Price Galleries, Chicago
Society of Canadian Artists Open Juried Show, Distinctive Merit Award
Elected President, Society of Canadian Artists (elected member in 1965)
Co-founded ART magazine

1970
Ontario Society of Artists Open Exhibition, Robert McLaughlin Gallery, Oshawa (catalogue)
Works of Art Committee Auction, Faculty Club, University of Waterloo (catalogue)
Society of Canadian Artists Open Juried Exhibition
Taught night school course in basic drawing, Northern Technical School
"Profile" a review of the artist, ART magazine, no. 4 Spring
President, Society of Canadian Artists
Member, Art Advisory Board, Toronto City Hall
Columnist ART magazine
Elected member, Ontario Society of Artists

1971
Ontario Society of Artists Open Juried Exhibition
Society of Canadian Artists Open Juried Exhibition, Purchase Award; article Globe & Mail, Apr. 14
Chairman, Professional Artists of Canada

1972
Agnes Etherington Art Centre spring exhibition, Queen's University, Kingston (catalogue)
One man show Lillian Morrison Gallery, Toronto—"Three Seasons"; article Star Week, Mar.
People or Planes Exhibition, Pollock Gallery
Guelph University—"The Mahler Cycle", an exhibition of paintings and drawings based on the symphonic works of Gustav Mahler
Ontario Society of Artists Open Juried Exhibition, Art Gallery of Ontario (catalogue)
Expressions—Cansave 1972, exhibition (catalogue)
Illustrated Christmas sermon "Psalm 139" for Metropolitan United Church
Taught at Hibb's Cove Art and Music Centre, Newfoundland; article Toronto Daily Star
Taught advanced painting Northern Technical School

1973
One man show Lillian Morrison Gallery, Toronto—"A Newfoundland Summer": article Globe & Mail, Apr. 21
One man show Gallery Fore, Winnipeg—"Tunisia/One Week of East", paintings based on a visit to Tunisia explorin design motifs of the Islamic culture
Society of Canadian Artists Exchange Exhibition, Honolulu, Hawaii
Created 12 acrylic works illustrating Christmas sermon "The Magnificat" for Metropolitan United Church, Dec. 16; televised on CBC Dec. 16
Pictures for a Christmas Service, Lillian Morrison Gallery, Toronto
Director, Hibb's Cove Art and Music Centre, Newfoundland
Completed series of 12 etchings entitled "All in the Family"

1974
Sir George Williams Annual Exhibition, Montreal
One man show Lillian Morrison Gallery, Toronto—"Sea Pictures of Newfoundland"
One man show Beckett Gallery, Hamilton—"Newfoundland Gothic", buildings and people of Newfoundland; article Hamilton Entertainer, Apr.
Society of Canadian Artists members exhibition, Shaw-Rimmington Gallery, Toronto; article Globe & Mail, Feb. 9
November Art Auction, Hadassah, Montreal

1975

One man exhibition Agnes Etherington Art Centre, Queen's University, Kingston (catalogue)

One man exhibition Shayne Gallery, Montreal—"The Sea, the Sky, and the Land"

Hadassah November Art Auction, Montreal; Award of Distinctive Merit

Joined the Roberts Gallery, Toronto

Member, Board of Directors, Visual Arts Ontario

Society of Canadian Artists members juried exhibition, Saint Mary's University Art Gallery and New Brunswick Museum and Art Gallery (catalogue)

1976

One man show Beckett Gallery, Hamilton—"The Pacific Rim", paintings and drawings of British Columbia

One man show Roberts Gallery, Toronto—"Paintings and Drawings", Newfoundland, Cobourg and Algonquin Park

One man show McMichael Canadian Collection, Kleinburg, Ontario; reviewed,
Toronto Sun, July 18, July 25, Aug. 1
Globe & Mail, July 24
Ottawa Journal, Aug. 28
Toronto Star, Sept. 2
Cobourg Star, July 26

Visual Arts Ontario exhibition, Hamilton Place and Scarborough Civic Centre

Art Gallery of Ontario, Art Rental exhibition, drawings and sculpture

Hadassah November Art Auction, Montreal

Member, Board of Directors, Visual Arts Ontario

Commissioned by the Ministry of Culture, Ontario; instructional book on acrylic painting

Commissioned by the Ministry of Culture, Ontario; 35mm. audio visual presentation

1977

Art Gallery of Windsor, feature artist at Art for All exhibition

One man show Shayne Gallery, Montreal—seascapes and pre-cambrian variations

One man show Gallery 1667, Halifax; reviewed,
The Spectator, Oct. 23
The Mail-Star, Nov.
The Chronicle-Herald, Nov. 4

Memorial University Art Gallery, St. John's, Newfoundland artists' greetings (catalogue)

Hadassah November Art Auction, Montreal

1978

One man show Roberts Gallery, Toronto—paintings and drawings of sea and land

Article, The Financial Post, Aug. 26, p. 19

One man show, Cobourg Art Gallery—paintings, drawings and graphics reviewed, Cobourg Daily Star, Sept. 11, p. 2; Sept. 19, p. 9.

Dofasco Collection, Art Gallery of Hamilton

Society of Canadian Artists "Two Decades", celebrating 20th Anniversary (catalogue)

Hadassah November Art Auction, Montreal (catalogue)

Member, Board of Directors, Visual Arts Ontario

Taught painting and drawing, Three Schools, Toronto

Juror, Ontario Arts Council

Five day workshop in painting and drawing, Quetico Centre

Produced first in a group of serigraphs under contract to Thielsen Publications, London, Ontario

1979

University of Guelph, Purchase Award

Member, Board of Directors, Visual Arts Ontario

Commissioned by Canada Post, $1.00 definitive stamp of Fundy National Park reviewed, Globe & Mail, Mar. 8, p. 1 and p. 14
Miami Herald, Jan. 28, p. 20H
Art Views, March/April, p. 9
Canada Post, Notice to Collectors

The Texture of Our Land, an exhibition opening the new Art Gallery of Peterborough

International Union of Tourist & Cultural Associations Exhibition, Istanbul, Turkey

Public and Corporate Collections

Sir George Williams University, Montreal
Queen's University, Kingston, Ontario
University of Guelph
Toronto-Dominion Bank
Dominion Foundries and Steel, Limited
Canadian Imperial Bank of Commerce
Manchester Shipping Lines
Shell Canada Limited
Kresge Collection, U.S.A.
Imperial Oil Limited
Art Gallery of Hamilton
Eaton's of Canada
Xerox Corporation
Art Gallery of Cobourg
Private collections, England, U.S.A., Holland and Australia

PAINTINGS

Image size is in inches with height first.
All paintings are acrylic on stretched canvas.
All drawings are graphite on 4 ply Strathmore or #172 Bainbridge board.

DRAWINGS

63 **Ruskin, John,** "Of Truth of Water", MODERN PAINT-ERS, Vol. 1, Part 2, Section 5, George Allen, 1888.

70/72 **Woolf, Virginia,** TO THE LIGHTHOUSE, reprinted with permission from the Author's Literary Estate and The Hogarth Press Ltd., London, and, copyright 1927, by Harcourt Brace Jovanovich Inc.; renewed 1955, by Leonard Woolf. Reprinted by permission of the publisher; THE WAVES, reprinted by permission from the Author's Literary Estate and The Hogarth Press Ltd., London, and copyright, 1931, by Harcourt Brace Jovanovich, Inc.; renewed, 1959, by Leonard Woolf. Reprinted by permission of the publisher.

74 **Conrad, Joseph,** TYPHOON AND OTHER TALES OF THE SEA, Dodd Mead & Co., New York, 1963.

77 **O'Neill, Eugene,** "Beyond the Horizon", Act 1, Scene 1. Copyright 1920 and renewed 1948 by Eugene O'Neill. Reprinted from AH WILDERNESS! AND TWO OTHER PLAYS, by Eugene O'Neill, by permission of Random House, Inc., New York.

78 **Lowry, Malcolm,** ULTRAMARINE, published by A.D. Peters Ltd., London.

81 **Conrad, Joseph,** THE MIRROR OF THE SEA, Wm. Heinemann, London, 1921.

82 **Melville, Herman,** MOBY DICK, Houghton Mifflin, The Riverside Press.

85 **Stevenson, Robert Louis,** "Early Impressions", THE AMATEUR IMMIGRANT, published in an edition of The Harvard University Press, 1966.

90 **Slocum, Joshua,** "Sailing Alone Around the World", THE VOYAGES OF JOSHUA SLOCUM, Rutgers University Press, New Jersey, 1958.

92 **Melville, Herman,** REDBURN, St. Bartolph's Society, 1924.

95 **London, Jack,** THE SEA WOLF, Arco Publications, London, 1966.

96 **Conrad, Joseph,** "Typhoon", TYPHOON AND OTHER TALES OF THE SEA, Dodd Mead & Co., New York, 1963.

98 **Monsarrat, Nicholas,** THE CRUEL SEA, copyright © Nicholas Monsarrat, 1950, reprinted with permission of Cassell Ltd., Publisher, London, and Alfred A. Knopf, Inc., New York.

104 **Woolf, Virginia,** THE WAVES. Reprinted with permission of the Author's Literary Estate and The Hogarth Press, Ltd., London, and copyright 1931, by Harcourt Brace Jovanovich, Inc.; renewed 1959, by Leonard Woolf. Reprinted by permission of the publisher.

107 **Dana, R.H.,** TWO YEARS BEFORE THE MAST, J.M. Dent, Everyman's Library, 1914.

112 **Pitseolak, Peter** and Eber, Dorothy. Peter Pitseolak in PEOPLE FROM OUR SIDE, reprinted with permission of Dorothy Eber and Hurtig Publishers, Alberta.

115 **Lowry, Malcolm,** IN MEMORIUM. ©1962 by M. B. Lowry

117 **Melville, Herman,** MOBY DICK, Houghton Mifflin, The Riverside Press.

119 **Psalm 107,** THE BIBLE, King James Version.

120 **Rasmussen, Knud,** "Song to the Sea", ESKIMO POEMS FROM CANADA AND GREENLAND, translated by Tom Lowenstein by permission of the University of Pittsburgh Press © 1973 by Tom Lowenstein.

123 **Price, Ray,** "Story of the Seal", HOWLING ARCTIC, by permission of PMA Books, Toronto.

129 **Synge, J.M.,** RIDERS TO THE SEA, published by J.M. Dent, Everyman's Library, London.

132 "The Banks of Newfoundland", traditional folk song.

134 **Picard, Max,** THE WORLD OF SILENCE, translated by Stanley Godman, 1952, Regnery/Gateway Inc., South Bend, Ind., and Eugene Rentsch Verlag, Switzerland.

136 **Birney, Earle,** "Atlantic Door", COLLECTED POEMS, reprinted with permission of The Canadian Publishers, McClelland & Stewart, Toronto.

138 **Birney, Earle,** "Gulf of Georgia" COLLECTED POEMS, reprinted with permission of The Canadian Publishers, McClelland and Stewart, Toronto.

140 **Heyerdahl, Thor,** FATU-HIVA, copyright © 1974 by George Allen & Unwin Ltd., reprinted with permission of Doubleday & Company, Inc., New York, Society Saiga S.A., Switzerland, and the Author.

142 **Whitman, Walt,** "On the Beach at Night Alone", COMPLETE POETRY AND SELECTED PROSE BY WALT WHITMAN, Houghton Mifflin, The Riverside Press, 1959.

BIBLIOGRAPHY

BIRNEY, EARLE (1904-)
"Atlantic Door", "Gulf of Georgia"
Collected Poems

Born in Calgary, Alberta, Birney has travelled and taught throughout Canada and abroad. He is not a lover of urban society, and has written with biting sarcasm about the loss of man's stature in today's highly pressured and largely trivial existence. *The Strait of Anian*, from which both our poems are taken, was published in 1948.

CAREW, JAN (1925-)
"Chaotic Epic"
Caribbean Voices 1 & 2

Born in the twenties of, as he is proud to say, mixed Negro, Dutch, South American Indian and Portuguese descent, Carew received a college education in the U.S., travelled widely working at jobs ranging from steelworker to actor, and now resides in England. He is best known as a novelist.

COLLYMORE, FRANK (1893-)
"Hymn to the Sea"
Caribbean Voices 1 & 2

Born in Barbados, he still lives there. He has taught English and edited magazines, as well as writing short stories and poetry.

CONRAD, JOSEPH (1857-1924)
**Typhoon and Other Tales of The Sea,
The Mirror of The Sea**

The son of a poet, Teodor Jozef Konrad Korzeniowski was born near Berdichev, in what was then Polish Russia. When he was five years old his parents were exiled to Siberia for involvement in a nationalist plot, and by the time he was twelve they had both died. After living with his uncle for a few years, Conrad signed up with the French and finally the English merchant marine, where he rose to the rank of captain. He became a British subject in 1885, and when it came to writing his novels he did so in English. At the age of twenty he had had no knowledge of the language, yet was later to become one of its greatest stylists.

DANA, R.H. (1815-1882)
Two Years Before The Mast

Dana was born in Cambridge, Massachusets, of an old and respected family. Just before enrolling in college he had a bout of measles, and in order to regain his health — so goes the excuse — he signed aboard the *Pilgrim* as a common seaman. The voyage was to last two years, going around Cape Horn and back, and it resulted in one of the finest accounts of life on board ship from that period. When he returned he studied law, and *Two Years Before The Mast* was published the same year he was admitted to the bar (1840). Because of his adventures he was never to be content with the conventional legal career that lay open to him. He fought to improve the lot of sailors and oppressed people everywhere. As a member of the Free Soil Party he provided free legal aid to negros captured under the Fugitive Slave Law. Wander-lust returned at the end of his career, and he died in Rome.

DRAYTON, GEOFFREY (1924-)
"Seeds of the Pomegranate"
from Caribbean Voices 1 & 2

Born in the British West Indies, the son of a sugar planter, Drayton graduated from Cambridge with a degree in Political Economy. He has taught English and Latin and his poetry has been published in a number of anthologies.

GROTIUS, HUGO (1583-1645)
Mare Liberum, 1609

Born in Delft, Holland, Grotius was something of a child prodigy. He entered the University of Leyden at the age of twelve and became a Doctor of Law when he was fifteen. He was among the first to suggest rules of conduct for war and peace, and modern international law has been developed largely on his principles. The quotation that introduces this book is taken from *Mare Liberum*, first published in 1609. In it, Grotius holds that waters not enclosed by land cannot be possessed by any one nation.

In 1493, Pope Alexander VI had declared that the uncharted oceans be divided between Spain and Portugal, at that time the apparent contenders. The seas were neatly halved by a longitudinal line near the Azores, with the west side going to Spain, and the east to Portugal. More than a century later the Dutch East India Company hired Grotius to argue on their behalf. They had seized a Portuguese vessel that had tried to bar them access to the East Indies. The result was *De Jure Praedae*, or *The Law of Prize and Booty*, in which Grotius concluded that the Dutch were acting in self-defence. The chapter entitled *Mare Liberum* was of such international interest that it was published separately, to the acclaim of other seafaring nations such as England.

It must not be thought that Grotius was merely a mouthpiece for his employers. Several years later, at the French Court, Cardinal de Richelieu made a characteristic statement that, in matters of state,the weakest are always in the wrong. Grotius replied that God and time would show the truth.

HEYERDAHL, THOR (1914-)
Fatu-Hiva

Dr. Heyerdahl is best known for *Kon Tiki*, *Aku-Aku*, and *The Ra Expeditions*. His life's work has been to prove that sea-travel played a large part in early population movements. When he was in his early twenties, he and his wife, Liv, went to live on the tropical Pacific Island Fatu-Hiva without the aid of medicine, supplies or outside aid of any kind. Our quotation is taken from the end of *Fatu-Hiva*, as Heyerdahl reflects on the relative advantages of modern civilization.

HOLMES, O.W. (1809-1894)
The Autocrat of the Breakfast Table

Although he was Professor of Anatomy at Harvard and wrote with distinction on medical matters, Holmes also produced an endless series of light essays that were published in the Atlantic Monthly. Some of these essays were printed in book form, one volume being entitled *The Autocrat of the Breakfast Table,* in which a boarder in a rooming house continually monopolizes the conversation. According to R. W. Emerson: "Holmes is the best example I have seen of a man of as much genius, who had entire control of his powers — so that he could always write or speak "to order": partly from the abundance of the stream, which can fill indifferently any provided channel."

KATAYAMA, TOSHIHIKO (1898-)
"Evening Song"
An Anthology of Modern Japanese Poetry

Best known as a scholar of German and French literature, Katayama has introduced many works in those languages to Japan.

KIPLING, RUDYARD (1868-1936)
"The Crab That Played with the Sea"
Just So Stories

Although he was educated in England, Kipling returned to the place of his birth, India, in 1880, where he worked as a journalist as well as writing many of the stories that gained him the Nobel Prize in 1907. The *Just So Stories* and indeed most of his output show the influence of his colonial upbringing. It has been fashionable to condemn Kipling as a heartless imperialist who spoke unfeelingly of "the white man's burden", but his stories show a genuine respect and affection for the people of India and other non-white nations.

KURODA, SABURO (1919-)
"The Sea"
An Anthology of Modern Japanese Poetry

As well as maintaining his poetic output, Kuroda edits the magazine *Poetry and Criticism*, and works for the Japanese Broadcasting Association.

LAYTON, IRVING (1912-)
"Tide"
Lovers and Lesser Men

Born in Rumania and brought up in Montreal, Layton is one of Canada's most respected poets. As Eli Mandel points out in his forward to *The Unwavering Eye*, McClelland and Stewart 1975, "... his style and form, various and capacious, depend for their success on what he himself has called the "imperial rhetoric of poetry, a vivid, fluent line and passionate language that scorn the levelling republican diction of younger writers".

LONDON, JACK (1876-1916)
The Sea Wolf

London grew up near the docks in San Francisco, and when he was fifteen embarked on a life full of the adventures he describes in his books. He was a sailor, a war correspondent; he was in the Klondike during the Gold Rush, and in *The Cruise of the Snark* he depicts a voyage around the world in a yacht. In *The Sea Wolf*, a gentlemanly author finds himself on a ship captained by the cruel and tyrannical Wolf Larsen. His man to man conflict with the Sea Wolf brings out his own courage and determination.

LOTI, PIERRE (1850-1923)
Stories of Pierre Loti

Pierre Loti is the pen name of Louis Marie Julien Viaud. Born in Rochefort, France, he became a naval officer, travelling to China, the South Seas and other exotic places that are the background to his books. His writing is characterized by a sensuous melancholy, almost impressionist in feeling.

LOWRY, MALCOLM (1909-1957)
Ultramarine, In Memorium

Best known as the author of *Under The Volcano*, Lowry was born in Merseyside, England, the son of a cotton broker and the grandson of a Norwegian sea captain. In his early twenties he escaped the comfortable confines of his upbringing by signing on board a steamer. His experiences are fictionalized in the novel *Ultramarine*.

MELVILLE, HERMAN (1819-1891)
Moby Dick, Redburn

Melville first went to sea in 1839 as a cabin boy on a trading ship. His experiences are the basis of *Redburn, his first voyage*, subtitled *"Being the sailor boy confessions and reminiscences of the son of a gentleman in the merchant service"*. In 1841 he sailed as an ordinary seaman aboard *Acushat*, a whaler out of New Bedford. After considerable experience in the Navy and another whaler, he produced *Moby Dick* in 1851. It was not popular with either press or public, who anticipated another travel-adventure in the style of his highly successful *Omoo* and *Typee*, and despite further literary output, he was forced to make a living as a customs inspector in New York City.

MILNE, A.A. (1882-1956)
"The Island"
When We Were Very Young

After a successful career writing plays and novels, A.A. Milne sat down to write out the bedtime stories he told his son, Christopher Robin. The results were *Winnie the Pooh*, *Now We are Six*, and other children's books that proved to be

more popular than all his other work. Christopher Robin Milne is himself the author of a fascinating autobiography, *The Enchanted Places*, McClelland & Stewart 1974.

MONSARRAT, NICHOLAS, (1910-)
The Cruel Sea

The son of a famous Liverpool surgeon, Monsarrat narrowly escaped becoming a solicitor and turned his talents to writing. *The Cruel Sea* is based largely on his experiences as a lieutenant on board a Corvette during the Second World War. It was and still is an enormously popular novel, and in the fifties was made into a movie starring John Mills.

NAMSON, CH'OE
"From the Sea to Children"
Poems From Korea

Korea's best known historian, Ch'oe Namson has edited many histories and literary classics, and pioneered the use of free verse in Korean Poetry.

O'NEILL, EUGENE (1883-1953)
Beyond The Horizon

After spending most of his youth touring with his father, the actor James O'Neill, Eugene O'Neill shipped to sea and lived a derelict's life during the five years he called his "real education". He began to write plays in 1914 and his first full-length play, *Beyond The Horizon*, won a Pulitzer Prize in 1921. It is about two brothers, one a dreamer and the other a realist, and the tragedy lies in the fact that neither of those qualities alone are enough to sustain a man.

PATCHEN, KENNETH (1911-)
"For Miriam, The Great Birds"
Collected Poems

The son of an Ohio steelworker, Patchen grew up to be an all-round athlete and honour student, attending the University of Wisconsin. Despite living in almost constant pain from a spinal affliction, he has poured out a great many books of poetry and prose, several of which he illustrated with his own drawings. In 1934 he met and married Miriam Oekemus, to whom he dedicated some of the finest love poems in the English language.

PRICE, RAY (1931-)
"Story of the Seal"
Howling Arctic

Price is a Baptist minister with a congregation in Yellowknife, NWT. In contrast to the stereotypical image of a man of the cloth, he has canoed down both the Mackenzie and Peace Rivers and spends much of his free time collecting stories both sacred and profane about the North.

RUSKIN, JOHN (1819-1900)
"Of Truth of Water"
Modern Painters

Ruskin was the most influential British art critic of the Victorian era. His sensibilities were steeped in Wordsworth and, perhaps because of a stern religious upbringing, he applied yardsticks of truth and morality to art. In *The Stones of Venice* he asserted that art is a visible reflection of the moral quality of the people who produced it, an idea which appealed profoundly to the era. With regard to the use of the word truth when talking about art, our quotations are from a section of his series *Modern Painters* entitled *Of Truth of Water*. The books were nominally dedicated to "The Landscape Painters of England", but Ruskin worshipped the paintings of J.M.W. Turner, constantly using them as examples. The first volume was rejected by the publisher, Murray, on the grounds that the public "cared little about Turner," but it was published later that year (1843) by Smith and Company. Although it was essentially a tribute to him, Turner disliked that critical acclaim of his own painting should depend so heavily on the disparagement of others.

PERSE, ST. JOHN (1887-)
"Narrow are the Vessels"
Seamarks

St. John Perse is the pen name of Marie René Auguste Aléxis Léger. Born in Guadaloupe, he had a brilliant career in the Diplomatic Corps, becoming Secretary—General to the Foreign Office until expelled by the Vichy government in 1940. At that time he moved to Washington, D.C., where he lived and wrote, eventually to win the Nobel Prize for literature in 1960. His work deals with the free-flowing imagery evoked by primal forces of nature such as wind and rain, and especially the sea.

PICARD, MAX (1888-1965)
The World of Silence

Picard had, in the words of Gabriel Marcel, "an intellect that *sees*". In his remarkable book *The World of Silence* he developes his theory that silence is at the heart of all existence and that man will find peace if he opens himself to that silence.

PITSEOLAK, PETER
in **People From Our Side**

People From Our Side is subtitled *An Inuit record of Seekooseelak—the land of the people of Cape Dorset, Baffin Island*. It is built around a manuscript written in Eskimo syllabics by Peter Pitseolak when he was seventy-one years old, as well as interviews conducted by several contributors. The text is accompanied by many thoroughly professional photographs taken and developed by Pitseolak over the years.

SHOENBLUM, SUSAN
"The Sea"
Miracles

Susan Schoenblum was eleven years old when she wrote *The Sea*. The poem is taken from an anthology entitled *Miracles: Poems by Children of the English-Speaking World*. It has a companion volume, *Journeys*, with selections in prose. If we may quote the jacket notes: "Both collections are intended not as a sampling of precociousness but as a testament to the stunning range of artistry and vision which children demonstrate when given the unfettered opportunity to write."

SHUNTARO, TANIKAWA (1931-)
"Sea"
Three Contemporary Japanese Poets

The son of a leading academic, Shuntaro methodically failed most of his examinations. In Japan, far more than in the West, such behaviour is considered very rebellious. He speaks for his contemporaries in a way that has made him very popular, and he has been widely published in other languages.

SLOCUM, JOSHUA (1844-1909)
The Voyages of Joshua Slocum

Born in Nova Scotia, Slocum went to sea when he was sixteen, becoming captain of an American schooner when he was twenty-five. After a long career in the merchant marine, he bought a derelict oysterman, *The Spray*, repaired it himself in thirteen months of labour, and sailed around the world alone. When he was sixty-five he planned a second voyage. After setting out from Vineyard Haven, Massachusets, in November 1909, he was never seen again.

STEVENSON, ROBERT L. (1850-1894)
"Sea Fogs"
The Silverado Squatters
"Early Impressions"
The Amateur Immigrant

The son of an engineer, Stevenson himself studied Law and Engineering at Edinburgh University, but eventually found that his true calling was literature. While still a young man he met Fanny Vandegrift Osbourne and the next year, 1879, ill with tuberculosis and quite penniless, he joined her in California. The long voyage is described in *The Amateur Immigrant*. They were married in 1880 and honeymooned near an abandoned silver mine, where he wrote *The Silverado Squatters*. In 1889 the Stevensons finally moved to Samoa, where he died in 1894.

SYNGE, J.M. (1871-1909)
Riders To The Sea

Born in Dublin, Synge studied music in Germany and was working in Paris when W.B. Yeats persuaded him to return to Ireland to write plays for the Abbey Theatre. He went to the Aran Islands, off the coast of Ireland, and lived there, on and off, for several years, producing the profound and moving account *The Aran Islands* and several plays. Scarcely more than a one-act play, *Riders to the Sea* manages to convey the true tragedy of fishermen and their families. It has been said of those days that if a mother served breakfast to two sons she could be certain that only one would be back for dinner.

TAKAHASHI, SHINKICHI (1901-)
"The Ocean",
An Anthology of Modern Japanese Poetry

After graduating from High School on Shikoko Island, Takahashi moved to Tokyo. In his twenties he lived and studied in a Buddhist temple for several years, and the influence of Zen thought can be found in much of his poetry.

THOREAU, H.D. (1817-1862)
Cape Cod

After graduating from Harvard in 1837, Thoreau tried unhappily to make a living in business and then school teaching, but concluding that too many men waste too much time on the unnecessary details of life, he decided to live as simply as possible and become an observer of nature. The major fruit of this life-direction was the classic *Walden*, written after two years of self-sufficient life in a small cabin. *Cape Cod*, published posthumously in 1865, is part history and part travelogue.

TRADITIONAL
"The Banks of Newfoundland"
The editors of *More Folk Songs of Canada* have this to say:

East-coast sailors and fishermen have sung at least half a dozen songs with this title. The most widely known, about the Irish lads who braved "the cold nor'westers on the banks of Newfoundland," appeared in *Folk Songs of Canada*. Like it, most of the others describe a sailing or fishing voyage in the narrative form of the come-all-ye. This local Newfoundland song is more lyrical than any of the others, with a pure pentatonic melody. Its simple verses convey both the beauty and danger of the wild sea, and the spirit of the men who wrest their living from it.

WHITMAN, WALT (1819-1892)
"The World Beneath the Brine, Sea Drift"
Complete Poetry and Selected Prose by Walt Whitman

Born near Huntington, Long Island, of a farming family, Whitman eventually moved to New York City where he worked as a journalist and editor. A warm-hearted, generous man who longed to loosen his own and everyone else's shirt collars, he was totally at variance with the moral tone of his time. His book *Leaves of Grass*, published in 1855, was hailed by Emerson and ignored by the public. He often turned to animals to serve as examples to man:
"They do not sweat and whine about their condition,
They do not lie awake in the dark and weep for their sins,
They do not make me sick discussing their duty to God, . . .
Not one is respectable or unhappy over the whole earth."

WOOLF, VIRGINIA (1882-1941)
The Waves, To the Lighthouse

Virginia Woolf was born in London, the second daughter of Sir Leslie Stephen. In 1912 she married Leonard Woolf, with whom she later founded the Hogarth Press. In her novels she disliked defining characters in terms of plot and events, preferring instead the technique of viewing the world from the standpoint of each character's "stream of consciousness.' In *The Waves*, published in 1931, six characters spend a day at the seashore from sunrise to sunset, and their thoughts interweave in an exploration of life from birth to death. After completing *Between the Acts* in 1941, she had a recurrence of a mental illness and drowned herself near her Sussex home.

YEATS, W.B. (1865-1939)
"To A Child Dancing in the Wind"
Collected Poems

Born near Dublin, Yeats spent his school holidays in the Irish countryside, where he absorbed the legends and folklore central to his plays and poetry. An ardent nationalist, he helped found the Irish National Theatre in Dublin and was a Senator of the Irish Free State from 1922-1928. Most of his poetry is mystical in nature.

DAVID BOLT

After graduating in 1966 with a degree in English Literature from the University of Toronto, where he took part in many theatrical events on and off campus, he accepted a position as editor on a business publication. But an offer to join the Stratford Festival Company was too tempting to refuse, and he has been a professional actor ever since.

He has played with many of the major theatre companies in Canada, including the Manitoba Theatre Centre and the St. Lawrence Centre in Toronto, as well as making numerous appearances on T.V. and Film. During his career, Bolt has played opposite many of Canada's best known stars, among them Gordon Pinsent, Frances Hyland and Heath Lamberts. He is recognized mainly for his contribution to "Alternate" theatre in Toronto, where he has been closely associated with the Factory Lab and Toronto Free Theatre. His many roles include the creation of Tyrone M. Power in George Walker's detective series and Johann Most in the stage and T.V. productions of Red Emma, by his wife, Playwright Carol Bolt.

His other writing credits include educational film scripts, poetry, and a recently produced full length play. He is currently writing a play for the 1980 season at Toronto Free Theatre.

GLEN E. CUMMING

Glen Cumming is originally a Westerner, born in Calgary in 1936. During four years of study at the Alberta College of Art, he was awarded the Queen Elizabeth Prize and three Alberta Government Visual Arts Scholarships, graduating in 1963.

He began his professional career as a painting instructor at the Edmonton Art Gallery. Soon he was appointed Supervisor of Art Education and then Assistant to the Director of the Gallery.

In 1967 Cumming moved from Director of Expressive Arts for the City of Edmonton, Parks and Recreation Department, to Curator of the Regina Public Library Art Gallery. Since then he has served as Director of the Kitchener-Waterloo Art Gallery, the Robert McLaughlin Gallery in Oshawa, and is currently Director of the Art Gallery of Hamilton, a position he has held since 1973.

Cumming has served in an advisory capacity on many boards including: Hamilton & Region Arts Council; Hamilton Public Relations Association; McMaster Medical Centre Art Gallery; Sir Sandford Fleming College, Training Committee, Ontario Museums Association, and Oshawa & District Council for the Arts. As well, he has served a term as, President, Ontario Association of Art Galleries; Chairman, Art Advisory Committee, Mohawk College of Applied Arts and Technology; and Board of Directors, Art Magazine.

Although Glen Cumming has spent most of his working years in land-locked areas, he boasts of a slight connection with the sea. For five years, he was lead drummer with the Navy Reserve Band HMCS Tecumseh in Calgary.

HUGH MACLENNAN

"I was born during an equinoctial blizzard on March 20 about three-quarters of a mile from the Atlantic shore of Cape Breton Island. During the birth my mother could hear the distant thunder of the sea in high storm as a north easterly gale drove the ocean against the rocks.

From the age of 7 to 21 I lived in Halifax, was there during nearly all of the First World War and during the great Explosion of Dec. 6, 1907. That event also came from the sea, as did the relief ships a few days later. Ironically, the first time I was ever further than fifteen miles from the sea was my first winter in England."

Hugh MacLennan is one of Canada's most distinguished writers. A Rhodes scholar, he has published six novels and an equal number of non-fiction books. He has been translated into 12 languages, has received five Governor-General's Awards for literature and the Companion of the Order of Canada in 1967. In 1979 he was made Professor Emeritus of McGill University, Montreal.

P. DURHAM DODD

Educated at Southmoor Technical College, Durham Dodd studied design and typography at the Sunderland College of Art, where he received the highest results in the third year final design exam after only completing two years of the program. Following four years of designing in a distinguished studio in Newcastle, he immigrated to Canada in 1966.

At the age of twenty-four he opened his own studio, Creative Resources Co. Ltd., in Toronto, which he has successfully operated for the past ten years. He has been a member of the Graphic Design Society of Canada since 1971 and is a former Vice President and Director of the Ontario Chapter.

He has served as a Design Judge for the Canadian Industrial Editors Association and for the Packaging Association of Canada, as well as being a guest lecturer at the Ontario College of Art. He has won five silver awards in Canada for design and one for photography in England, has three awards of excellence from Italy and 'The Highest Standard' award for design from New York.

"... Born about three miles from the North Sea Port of Sunderland, England, my youth was spent with the fishermen among the trawlers and fishing cobbles moored in the various harbours of Northumberland and Durham. I have experienced many pleasures and hardships during my association with the sea—from fishing and sailing its waters to helplessly witnessing the tragedy of the Foyboatmen volunteering their lives in duty, during the 'Seaham Lifeboat Disaster'."